RESIDENT EVIL.
biohazard

DOCUMENT FILE

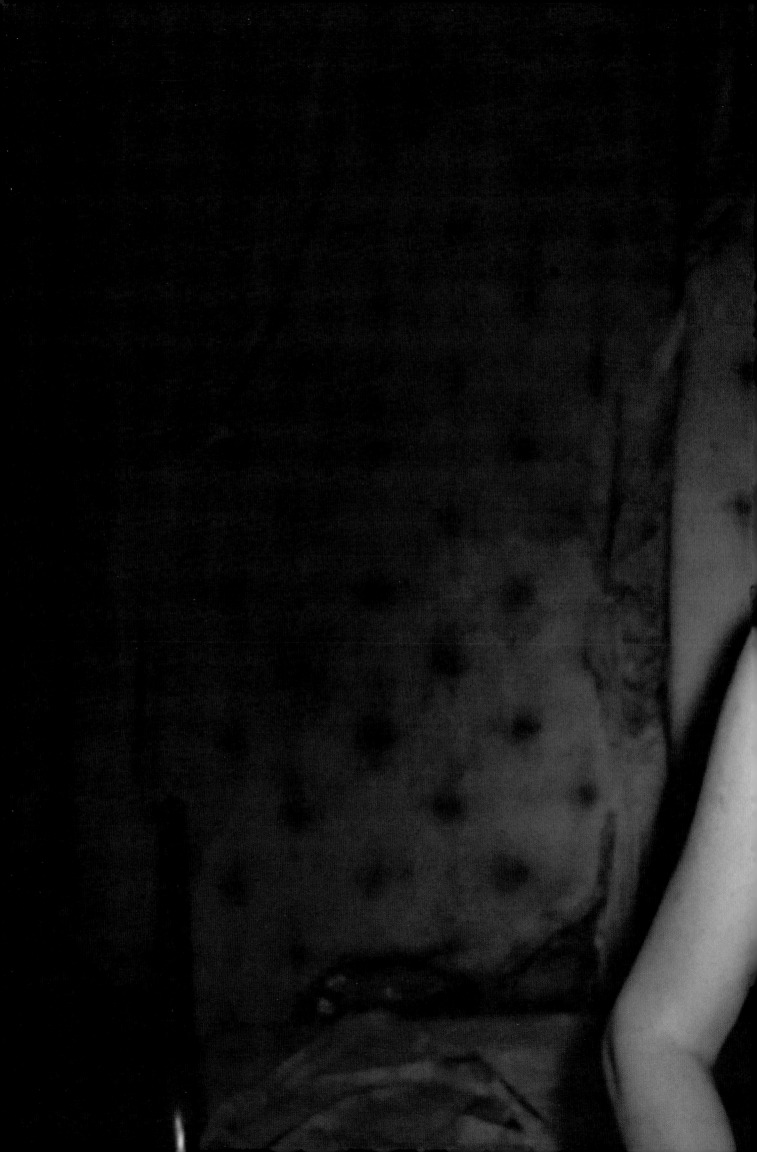

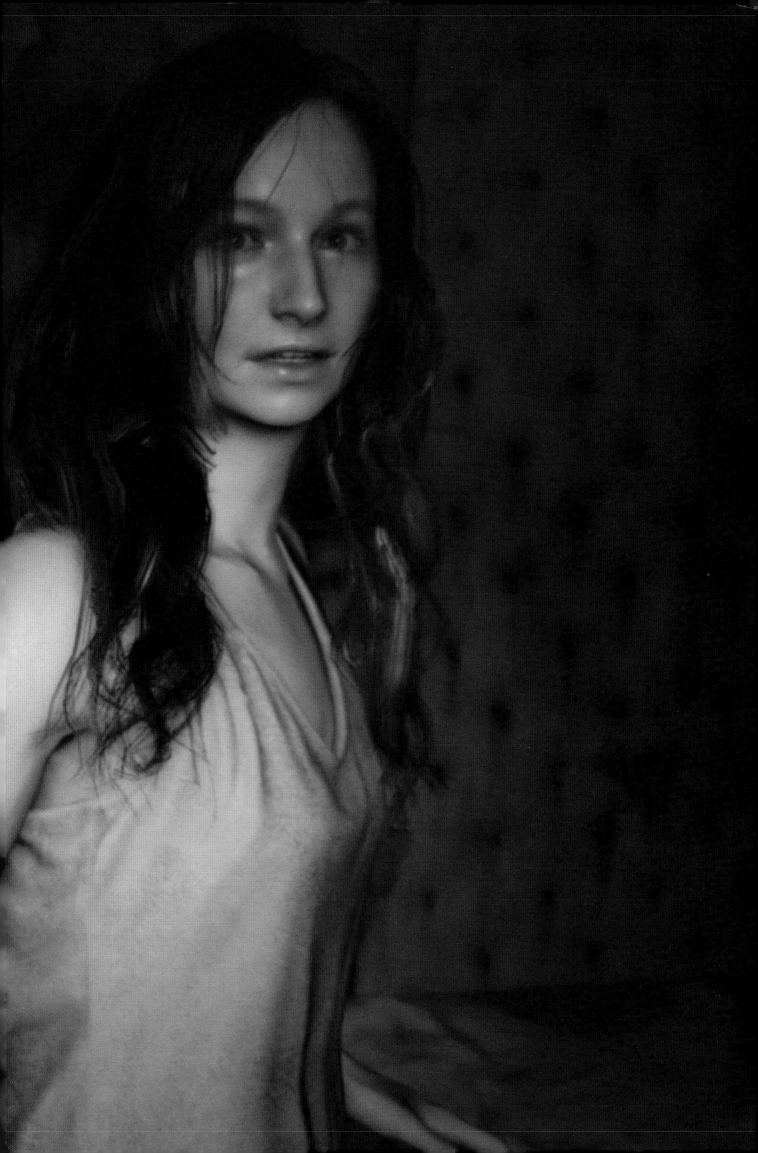

INTRODUCTION

From September 2015 to January 2017, Dengeki PlayStation Editorial Department published a 14-volume long-term, close-coverage Inside Report* about the development team's work on *Resident Evil 7: Biohazard*. This book builds upon those articles, adding new post-release episodes and countless pieces of concept art.

*Dengeki PlayStation, Vols. 618–632 (Writer: Shiwasu Toru, Editor: Dengeki PlayStation Editorial Department)

With that in mind, we recommend you play *Resident Evil 7: Biohazard* before reading this book. The contents of this book may be considered grotesque by some readers and are not meant for the weak of heart or those under 18—for this, we ask for your understanding.

Each Inside Report section will use concept art to show the narrative's progression, but, be aware that we do use screenshots in the Bonus Gallery in the back. The screenshots used will have a monochrome print to lower their influence on the gameplay as much as possible. (This is a spoiler, but it won't contain as much information as the actual screen.)

As mentioned above, this is not just a collection of documents and artwork. It's a non-fictional development documentary. *Resident Evil 7: Biohazard* has undergone many changes from early development until now, even taking on PS VR. Various confidential creation stories and development documents from those involved show the trajectory of that challenge. The aim of this book was to be interesting for all those who want to create, not just those currently in the industry or intending to be a developer hereafter. Although this book is entirely unusual from the coverage to editorial system, there is no greater joy for those involved than the readers finding some value within.

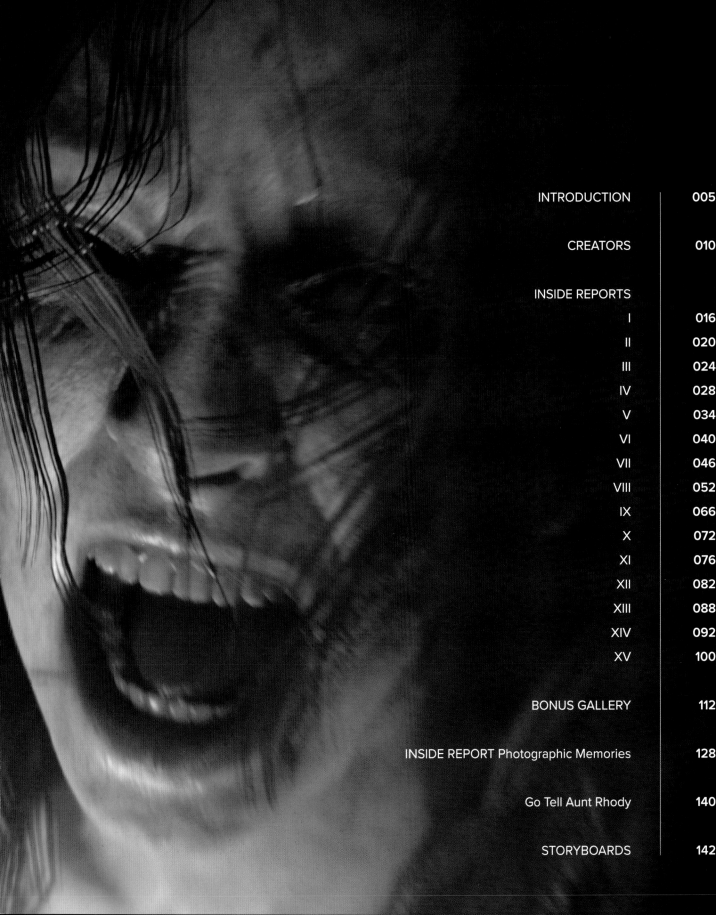

"I should make the best possible
Resident Evil I can."

—*Jun Takeuchi*

Capcom employee for twenty-five years, Takeuchi was coming up

on his forty-sixth birthday. When he thought about how many more

games he'd get the chance to make in his life, he felt that time

couldn't be wasted on an unsatisfactory product.

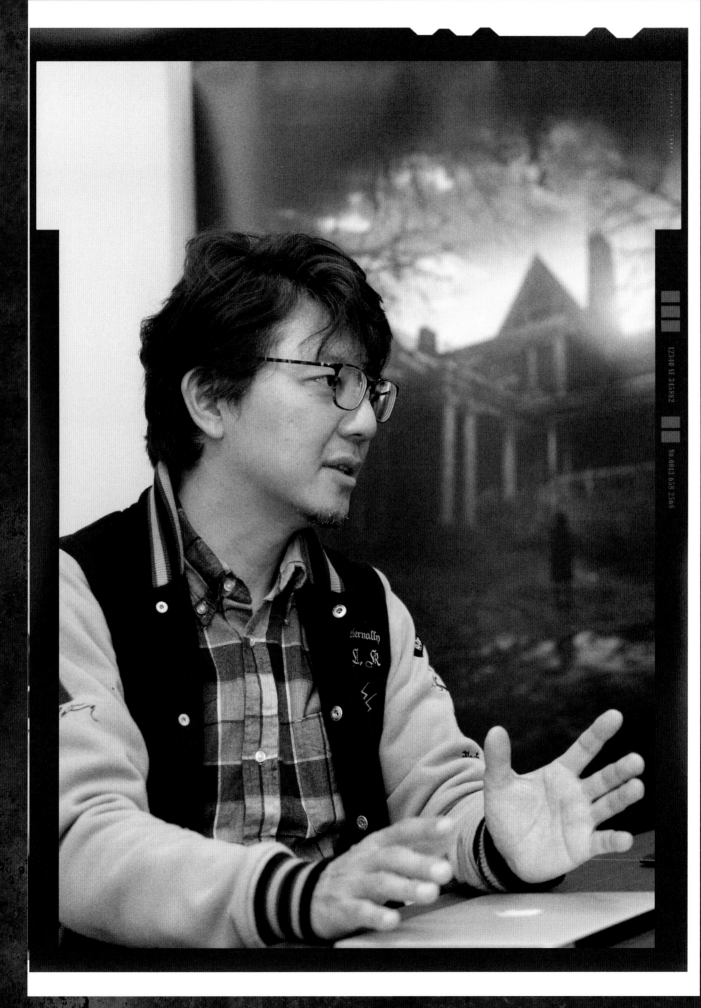

Photo by Satoshi Tokui

Resident Evil 7: Biohazard Document File

CREATORS

CHIEF CREATORS OF *RESIDENT EVIL 7*

There were many more people involved in the project. The actual development plan was born from Jun Takeuchi, who took command of the production system's general framework, and the idea of Director Koshi Nakanishi, with the help of project managers Makoto Kadono, Yoshizumi Hori, and Hiroyuki Chi.

Head of Development
Jun Takeuchi

Director
Koshi Nakanishi

Producer
Masachika Kawata

Producer
Tsuyoshi Kanda

Project Manager (and Art Director)
Hiroyuki Chi

Project Manager
Makoto Kadono

Project Manager
Yoshizumi Hori

Art Directors	Tomonori Takano		Shogo Fujishima		Tadashi Noyama
	Toshihiko Tsuda		Shinichiro Biwasaka		Shinya Yoshimoto
Project Managers	Hakuei Yamamoto		Yusuke Tokita		Seiya Iwasaki
	Tsubasa Miyamoto		Hiroshi Yamashita	Technical Director	Makoto Fukui
Game Designers	Tomohiro Shingu		Mao Hikichi	Environment Artists	Hiroto Teraoka
	Hajime Horiuchi	Level Designers	Hirotada Miyatake		Yasuyuki Maeda
	Keisuke Yamakawa		Hirofumi Orita		Masanao Yamazaki
	Morimasa Sato		Yasufumi Kayo		Hiroshi Sugiyama
	Kentaro Nihei		Shinichi Nishihira		Yuta Kakegawa
	Isamu Hara	Character Artists	Hirofumi Nakaoka		Atsushi Yoshimine
	Masanori Komine		Tsutomu Ohno		Miyuki Yakushiji
	Yukio Nishimura		Riccardo Minervino		Isshin Sakurai
	Yuta Kawashima		Keiji Nakaoka		Yoshiaki Sakurai
	Tsubasa Saimen		Yosuke Yamagata		Akio Kamiji

	Natsumi Furuya	Masaki Sugita		Yoshito Kato
	Chieko Ryugo	Yuichi Nishio		
Prop Artists	Shogo Takahashi	Koji Kanemori		Mitsutoshi Kodama
	Tatsuya Ogawa	Masao Ueda		Sayaka Yaegashi
	Koji Nagano		Composers	Akiyuki Morimoto
	Chikako Kijima	Programmers Yosuke Noro		Miwako Chinone
Concept Artists	Ward Lindhout	Naoki Hashimoto		Satoshi Hori
	Rintaro Komori	Toshiaki Yonezawa	Sound Programmers	Kenji Kojima
Animator/Cinematic Animator	Masato Miyazaki	Takahiro Tsuboi		Yusuke Kinoshita
Animators	Yuki Yanagimoto	Keisuke Mizutani	Cinematic Sound Designers	Gaku Komura
	Keiichi Sato	Ryo Narita		Arata Iwashina
	Yoshihiko Akita	Noboru Hidaka	Dynamic Mixing Engineer	Kazuya Takimoto
	Masafumi Kimoto	Masaharu Kamo	Foley Recording Engineer	Takashi Moriguchi
	Yuji Kimura	Tsutomu Terada	Assistant Engineer	Ryota Takei
	Syofu Ohashi	Tetsuro Noda	Sound Studio Coordinator	Setsuo Yamamoto
	Yukio Seike	Kenichi Saito	Sound Manager	Motoi Kishimoto
	Kohei Okumura	Vanus Vachiratamporn	Video Editors	Akira Tsumuraya
	Akiko Shibata	Hiroshi Omachi		Yuki Hoshino
	Masaya Ueda	Hiroshi Hattori	MoCap Operators	Katsumi Kobayashi
Facial Animator	Hiroko Ihara	Fuya Oyachi		Ikuo Nakayama
In-game Cinematic Animators	Tsuyoshi Irie	RE ENGINE Staff Tomofumi Ishida		Tsunenori Shirahama
	Toshiya Kotani	Masaaki Korematsu Kazuhiro Takahara		Naoki Fujisawa
	Sasuke Nakano	Shunsuke Saito Kazuma Mori		Masahiro Nakano
	Naoki Tanimoto	Tsukasa Murayama Yusuke Ichiyama		Takeshi Nose
	Junya Yamamoto	Kensaku Fujita Yuki Sekino		Senichi Kaetsu
Visual Effects Artists	Kazumasa Kuroda	Yasuhide Sawada Masashi Okubo	MoCap Actors	Yoshiaki Yuasa
	Koshi Watamura	Toshihiro Yamauchi Takumi Yamada		Masatoshi Fukidome
	Masahito Aiso	Tomohiro Shimizu Seiya Sugo	Manual Designer	Shinichiro Komizu
	Keisuke Ando	Yasuto Tsuchisaka Hitoshi Mishima	Submission Team	Nobuya Yoshizumi
	Zihao Hu	Akihiro Shimizu Haruna Akuzawa		Hiroshi Yamaguchi
	Koji Chijiiwa	Shusuke Iwasaki Ojiro Tanaka		Kotaro Fujioka
Lighting Artists	Yuka Chi	Adam Clapsaddle Daisuke Sanekane		Takuya Kamiura
	Shinichi Taniguchi	Stefanus Nanami Teppei Yoneyama		Shuichi Sumida
	Ayako Kato	Tatsunori Aoyama Shigeki Niino	Global Promotion Manager	Tsutomu Masuda
	Haruka Akiyama	Takaya Nishii Yuki Noto	Promotion Producer	Manabu Okamoto
	Dairi Hayakawa	Soichi Uchiyama Akiyoshi Takahashi	Publicity Manager	Kenichi Hashimoto
	Shinji Kajihara	Haotian Ding Kenta Yamaki	Publicity Team	Norio Tanaka
	Masaaki Kosaka	Kazuya Okada Sho Kitami		Jun Matsumoto
Destruction Artists	Takami Taki	Tatsuya Okamoto Toshiaki Morimoto		
	Yuichi Akimoto	Koichi Kubo Hong Hu		
	Jumpei Yamada	Zhicheng Zhu Takakimi Hashimoto		
	Ryusuke Yamada	Koji Misu Daigo Matsuura		
	Hiroki Nakanishi	Masatoshi Nakamura Takefumi Tahara		
UI Designers	Masahiro Takayama	Audio Director Wataru Hachisako		
	Junya Nishino	Sound Designers Yuji Higashiyama		
		Ken Usami		

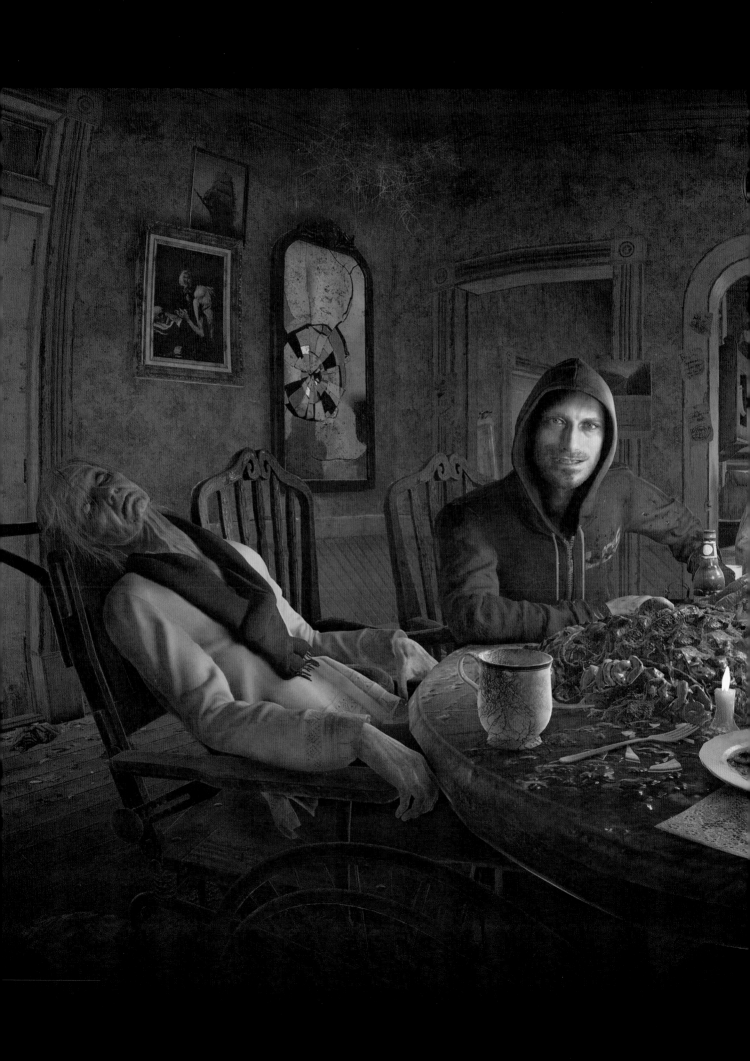

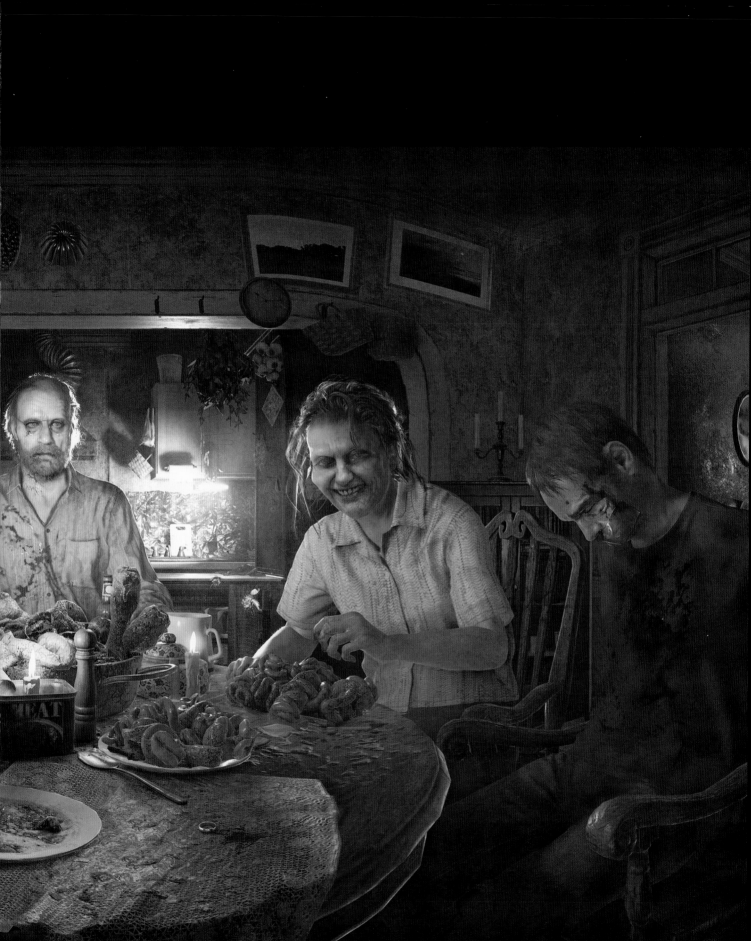

COLUMN I: A TYPE OF TRUE FUNGUS

TEXT: DENGEKI STRATEGY GUIDE EDITORIAL DEPARTMENT

Mold is a type of eumycete that adapts to all conceivable environments and grows everywhere on Earth. Biologically, it's a word used only for a certain type of true fungus. Eumycetes— including everything from blue mold (penicillium) and the aspergillus that grows on malt to the yeast fungus used in fermenting bread, and shimeji, enoki, and matsutake mushrooms— adapt to a great variety of environments. This adaptability is among the best in the living world—some molds can open holes in the sturdy aluminum alloy tanks of jet engines, "eating" the aluminum, while others are known to grow in sulphuric acid and insect repellent. Mold even grows on the No. 4 nuclear reactor in the Chernobyl Nuclear Power Plant despite its highly radioactive nature after the explosion in 1986.

In contrast, mushrooms are easier to imagine when it comes to mold. Like matsutake on pine trees or shimeji on deciduous trees, each has adapted to an environment in which they can thrive. The mushrooms that sprout on animal cadavers and the parasitic caterpillar fungi on insects are similar to these mushrooms. In other words, they are from the same category of fungi. These eumycetes look like fluffy masses of fungal filaments to the human eye, and this state of mycelium is generally known as "mold." The mycelia of mushrooms, however, spread densely in the earth under the fruiting body. Even in the yeast cells used in bread making, colonies of mold begin to form on the dough once fermentation has reached its limit. Among fungi, those that exist only as spores and mycelia in their lifetime are known as "mold." However, when they become mycelia, it's impossible to determine what kind of fungi they are without a microscope or DNA test. Therefore, the thing we know as "mold" is not simply a word to describe a certain type of true fungus, but can be understood in a broader sense that encompasses things from yeast to mushrooms.

INSIDE REPORT

I

THE MEANING OF THAT MOMENT OF SILENCE

It was June 14th, 2016, at 9:30 a.m. JST.

Resident Evil series producer Masachika Kawata and a number of other staff members were in Los Angeles, waiting with anticipation and anxiety. They were at the world's largest video game event, E3 2016. This show had the attention of gamers worldwide and the team was about to announce a game. It was the latest installment of a series that Capcom poured their heart and soul into, a series with international acclaim.

The E3 2016 PlayStation Press Conference finally began at 10 a.m. JST. A series of "Triple-A" titles (games produced by mid-sized or major publishers) for PlayStation 4 were announced, filling the venue with cheers each time.

Twenty minutes into the conference, the room was shrouded in an eerie silence. A trailer started.

The audience's eyes were glued to the screen. The first thing they saw was a black phone, ominously ringing. Next, there was a dilapidated house. A corpse was sprawled on the ground. There was something that resembled organs and then some mysterious characters. As

they watched in silence, everyone doubtlessly believed this unidentified, terrifying video must be some new horror game.

But at the final moments, when the title appeared, not only the press and industry people packed into the venue, but also gamers watching the live stream around the world thunderously cheered.

It was *Resident Evil 7: Biohazard*, the long-awaited new installment of the *Resident Evil* series.

Incidentally, if you take a look back at the live stream, you may notice something. I'm referring to the moments between when the title appeared and the applause began. The meaning of that moment of silence was perhaps what Kawata and the rest of the staff had hoped for. The unexpected announcement of *Resident Evil 7* caused confusion; the revelation that what the audience thought was a whole new series was in fact *Resident Evil* caused shock, and the cutting edge, realistic graphics of this new installment caused awe. This massive change from the series thus far left everyone in silence for a moment before all their emotions converged into delight.

Kawata and the rest of the staff were undoubtedly relieved to see this reaction. *Resident Evil 7*'s introduction to the world was received as planned, possibly even better than planned, and they got to witness the instant it happened.

Until this announcement at E3 2016, they had been hiding *Resident Evil 7*'s existence. In our internet-based information society, you are unlikely to find a Triple-A title that has leaked so little information in advance. The surprise was only possible because of the hard work of the *Resident Evil* team.

That effort more than paid off. News of the new, never before mentioned, *Resident Evil* game rapidly spread across the globe.

Gamers around the world had most certainly been waiting for this news.

The first *Resident Evil* was released in Japan on March 22nd, 1996. Over the next twenty years, the series went through numerous daring evolutions, gaining more fans each time, to the point where it's now known to anyone, not just gamers.

And then, at last, information on the seventh game impacted the world.

001

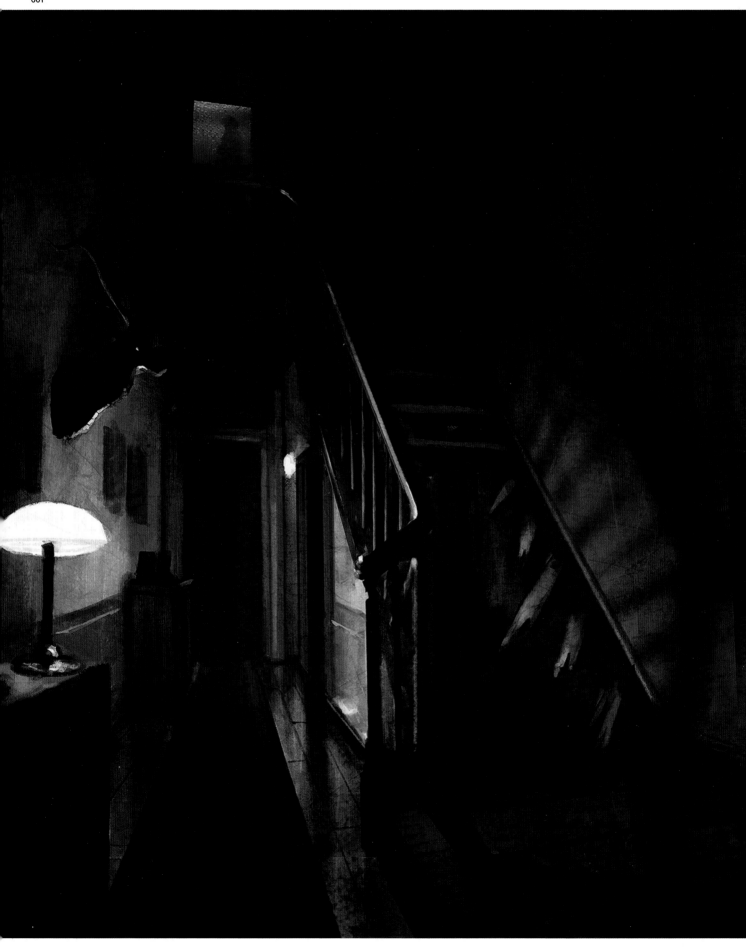

As I'm sure many readers already know, *Resident Evil* is trying to go in a considerably different direction with *7*. The intention is to return to the core of the series but in an evolved form.

The terrifying graphics are the first thing to catch the eye. For the development of *Resident Evil 7*, Capcom created a new engine known as the *RE* Engine. It's capable of producing photorealistic images on the level of live-action movies, not only through how it renders various objects but also with dust and other such details in the atmosphere. Originally created for *Resident Evil*, the *RE* Engine is truly next generation, and Capcom intends to use it on many future titles.

Resident Evil 7's most revolutionary changes are in the gameplay department. The view has switched from a third-person perspective to "Isolated View," a first-person perspective. The setting is a sinister house as in the first *Resident Evil*—there's no sign of any existing *Resident Evil* characters. It's not just the enemies; the details of the protagonist have also been entirely unpublicized.

A *Resident Evil 7* demo was also released when the game was announced. The surprise of receiving a demo on the day of the announcement garnered shouts of delight and many reactions from gamers around the world.

The one who paid the most attention to gamers' reactions on that day was most likely Kawata. While he was relieved by the response to the game's debut, he watched the following situation with a cool head. Kawata was the series producer for *Resident Evil* and had the duty of making certain the project succeeded.

The previous game, *Resident Evil 6*, sold 6.7 million copies internationally. It wouldn't be odd for a sequel to follow in the footsteps of the game that preceded it.

But *Resident Evil 7* didn't do that. Why, as series producer, did Kawata take on the riskier option of going in a new direction?

To understand why, you need to know what Capcom's CEO, Kenzo Tsujimoto, always tells his employees:

"Always strive to make the best stuff you can."

Jun Takeuchi, the manager of development on *Resident Evil 7*, took those words to heart.

Takeuchi had two ideas in mind. One was to do what Tsujimoto said and make the best stuff he could.

The other was to solve some long-persisting issues in the Japanese game industry of ever-rising production costs and the need to develop new talent. Takeuchi wanted to construct a more efficient development environment and, most importantly, help develop new talent for the next generation. When Takeuchi was designated general manager of the *Resident Evil 7* project, the first thing he asked the team was, "What is *Resident Evil*, really?"

If, for example, the team wanted those who enjoyed the first *Resident Evil* to be reminded of the fear they felt while playing it for the first time, they had to be careful not to simply copy the first game lest they produce a game that only exists for nostalgia's sake. What was needed was a new type of horror game, but one that still had what made *Resident Evil* interesting. Takeuchi's first step, both toward the production of *Resident Evil 7* and the production of the next generation of talent was to ask each member of the team, "What is *Resident Evil*?" He managed the development environment while helping new game developers grow. In other words, he "made good stuff."

It was only natural that Kawata, who also long worked at Capcom and oversaw the *Resident Evil* series, agreed with Takeuchi's efforts.

Of course, they had no idea whether this very unconventional *Resident Evil* would be well received by the series' longtime fans. That is why, following E3, Kawata paid close attention to the response from gamers.

The results: The conference hall was filled with shouts of shock and joy. Reaction videos showing the instant fans saw the announcement were uploaded all over video sharing sites. Videos where fans

literally jumped for joy became a topic of discussion.

The demo also received widespread reactions. There was, as it turned out, some confusion over the extreme changes to the *Resident Evil* series. But far exceeding that were impressions like the following:

"I was too scared to go on."

"Even my own footsteps scared me."

"I couldn't even get myself to go to the bathroom."

They all agreed on one thing:

"It's actually scary."

That was what Kawata, as well as Takeuchi and the rest of the development staff, hoped for.

Gamers look at the release of a famous series' newest game almost like a holiday. But before that glorious day, there are days upon days of struggle. How did *Resident Evil 7* become what it was? What were the challenges faced along the way? This report details the path leading up to the announcement at E3, and the steps following that up to the game's release. Starting on the next page, let's examine the birth of *Resident Evil 7*.

001

Concept art from the early development phase. Title: stairs. Darkness looms at the back of the stairs, as does the shadow of a person upstairs. The forlorn light from the lamp escalates the sense of dread.

002

Early concept art of the entrance hall. A drafty entranceway. Light illuminates it from the outside, giving off a slightly different impression of the Baker residence, which is the setting of the game. The twin staircases along with the decorative clock indicate a wealthy lifestyle.

002

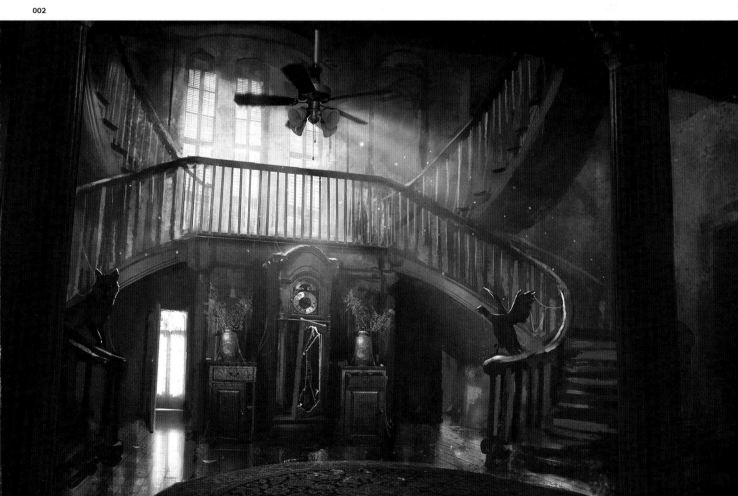

INSIDE REPORT

II

THE BIRTH OF *RESIDENT EVIL 7: BIOHAZARD*

Game developer Jun Takeuchi has worked closely on the *Resident Evil* series since the first game's release in 1996, even working as the producer on *Resident Evil 5*.

On January 4th, 2014, Capcom's first workday of the new year, CEO Kenzo Tsujimoto called Takeuchi to his office and said "RE's been having some trouble. Can you take care of it?"

At the time, development of the latest *Resident Evil* was in a rough spot. *Resident Evil 6* had sold 6.7 million copies, satisfying many gamers with its ensemble cast of appealing characters and strong action elements. However, with the increasing focus on action, the horror elements conversely decreased. Longtime fans had mixed opinions.

It was probably only natural that the next numbered title would be unsure of which direction to go in. They couldn't retread the same ground as *RE6*, but it wouldn't be easy to change the successful parts. The new game ran into a wall in its early planning stages.

Tsujimoto wanted to break through that wall by putting Takeuchi, who long had deep connections with *Resident Evil* and

already supported the project from a management position, back on the front line.

Considering the situation, being tapped by Tsujimoto would make just about anyone hesitant. He was being entrusted with the new *Resident Evil*, and the pressure of carrying the series was heavy indeed.

Although the sudden request caught Takeuchi off guard, he wasted no time in responding.

"Understood. Allow me to take the project."

His answer came instantly. That moment was the true beginning of *Resident Evil 7*.

Tsujimoto's trust may have been just that inspiring. But why did he take on the inevitably daunting task of *Resident Evil 7*'s development? Takeuchi had no particularly complicated reason for it.

Anyone else might have had reservations. But Takeuchi thought, if it was going to be that difficult, it's best to take up the challenge without letting anything hold you down.

Thus, Takeuchi became the manager of the *Resident Evil 7* project, but he wouldn't

figure out exactly what action to take until about a month later.

Takeuchi spent that month thinking long and hard about what to do.

He had two ideas from the start. One was to make the best stuff he could.

The other was to solve some long-persisting issues in the Japanese game industry—namely, ever-rising production costs and the need to develop new talent. Takeuchi wanted to construct a more efficient development environment and, most importantly, help develop new talent for the next generation.

First, he considered how to make "good stuff."

The *Resident Evil* series thus far had been developed by well-established creatives. However, paying too much mind to the content of previous games in the development of this one would only hold him back.

It was the methods used to develop previous *Resident Evil* games that were really worth learning from. Looking back, each game in the series had a "core" image. The

003

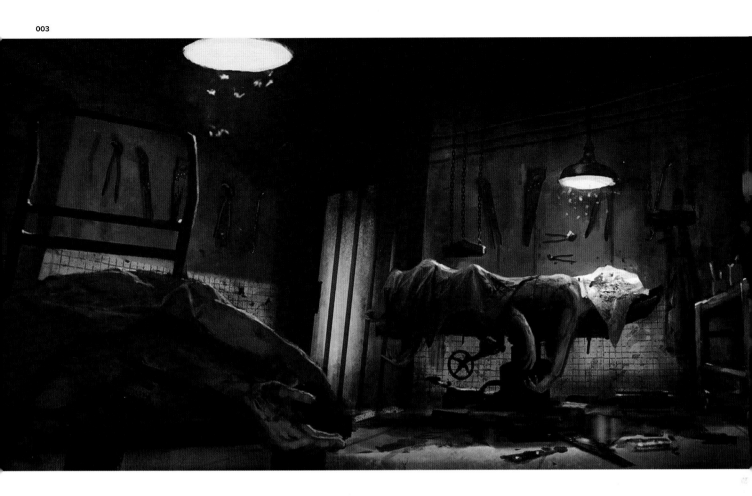

004

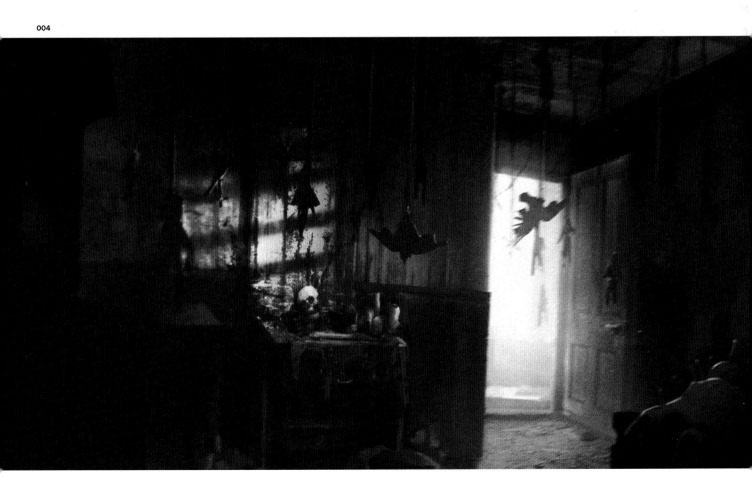

first game had its sluggish zombies, and *RE4* had the "Chainsaw Man."

Thanks to his close involvement with the development of many *Resident Evil* games, Takeuchi knew that well. He started with the game's core image, then, by sharing that image with the entire staff, he was able to create a game with a strong backbone. What was important was how they expanded from that core and whether the many staff members could stick to the image. Teaching this method would be the

first step toward developing the next generation of talent.

He also considered his own age. A Capcom employee for 25 years, Takeuchi was coming up on his 46th birthday. When he thought about how many more games he'd get the chance to make in his life, he felt that time couldn't be wasted on an unsatisfactory product.

"I should make the best possible *Resident Evil* I can."

With that decided, Takeuchi's next step was to determine what his personal favorite elements of *Resident Evil* were.

What is *Resident Evil*? It's a horror game more than anything. Associated with that is the idea of exploring an area where dangerous enemies lurk. It's the nerve-wracking sense that something could attack at any time and the demand to fight with the limited resources available. Strong weapons could stop any foe from being frightening, but there are always limits on ammo. If the

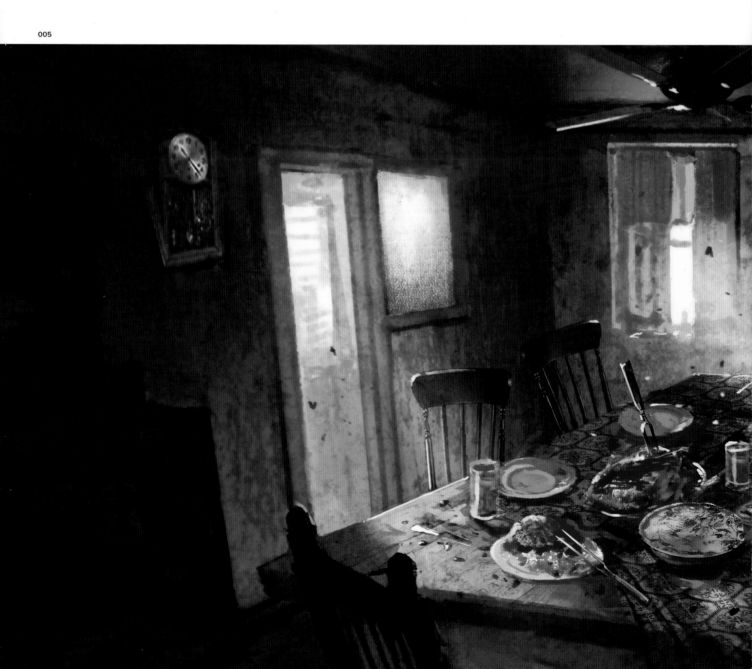

items you're relying on run out, the terror instantly multiplies. These are the elements that have carried on throughout the series and those that could be taken to the next level on next-generation platforms.

A switch to a first-person perspective could likely intensify the spine-tingling elements of the game. Takeuchi decided that, if possible, a first-person perspective was the way to go. Even at this early stage, *RE7* had already begun to set itself apart from the rest of the series. Takeuchi didn't hesitate

to make changes from past installments if those changes were necessary to produce the best possible *Resident Evil*.

At the time, open-world games were a worldwide trend, but Takeuchi felt that style of large-scale games wasn't a good fit for the Japanese—especially not for Capcom's development teams. What the Japanese excel at is craftsmanship, taking one element and using it to its fullest potential. In other words, it's the "narrow, yet deep as possible" approach.

After putting it all together, Takeuchi knew what he wanted to do. He wanted to create the scariest *Resident Evil* yet. And bringing out the horror certainly wouldn't take many combat elements. The setting also didn't need to be that large, nor did there have to be many different enemies. He wondered whether the online aspects we expect in every big game nowadays were really necessary; horror games are scariest when played alone.

However, taking that approach revealed another problem. The way of the industry was always to make each big release larger and flashier than the last. Would gamers accept a game that was narrow and deep, the antithesis of that idea? And how much of the staff would go along with it?

The assembly of an all-new *RE7* development team was about to begin.

003
Early concept art. The underground surgery room. A blasphemous scene: arms dangling from haphazardly placed bodies.

004
Early concept art. A room covered in red carpet. The myriad dolls hanging from the ceiling and the dusty quality—suggesting no one has come in for some time—create an ominous air.

005
Early concept art of the kitchen. Lumps of meat left on the table with carving forks stuck in them, accompanied by swarms of bugs.

INSIDE REPORT

III

ASSEMBLING THE *RESIDENT EVIL 7* TEAM

Having taken charge of *Resident Evil 7*'s development, Takeuchi needed to put together a development team. That team, of course, had to be perfect for creating his ideal *Resident Evil*.

To people outside of the company, Takeuchi is known as the executive producer of *RE7*, but as the person who conceived of the developmental approach to the game, the team decided to call him the project's "owner."

The title "owner" may give the sense that he was in possession of something in particular, but under their development approach, it meant he was the overseer of the project. He was the one who always gave them direction, as well as the one who checked out the game at specifically set times, taking the perspective of the "first player" and giving his impressions on the finished work. Takeuchi had a lot of authority, of course, but at the same time, all responsibility for what happened to the project fell on him.

As development continued, the search began for the talent who would make up the team's core.

Takeuchi first called on Koushi Nakanishi. He had experience working as the game

designer of *Resident Evil 5* and the director of *Resident Evil: Revelations* at Capcom. Contrary to the impression given by his large stature, he possesses a keen analytical ability and a penchant for working with others. In order to spread his "narrow and deep" philosophy throughout the whole team, Takeuchi believed a man like Nakanishi should be at the center of the project.

Nakanishi signed on surprisingly quickly after hearing Takeuchi's ideas for the project.

At this time, Nakanishi didn't entirely agree with Takeuchi's "narrow and deep" way of thinking. However, *RE7* was expected to face difficulties, and Nakanishi's reservations were outweighed by his agreement with the daring idea that it was best not to be held down by the past. Nakanishi decided it was worth a shot.

Thus, as a first step, Nakanishi was made the director.

It's worth noting that, in the past, when a game was being developed, the director was responsible not only for the quality of the product, but also for managing the staff and the schedule. Budgeting, negotiating with the advertising and sales depart-

ments, and keeping everything together was the producer's role.

But now that game development has expanded to the point where selling a game internationally is just a matter of course, this role distribution has gone through considerable changes. Project schedules have become too expansive for directors to manage while working on a game, and a single producer can no longer handle budgeting as well as international advertising and sales. What a Triple-A game like *Resident Evil 7* needs is a project manager, someone solely responsible for setting up a long-term schedule for the many staff members. For that position, Takeuchi called someone else at about the same time as Nakanishi.

His name is Makoto Kadono. A man who joined Capcom as a programmer, he also worked on *Resident Evil 5*. Kadono knew the importance of schedule management better than anyone, and had the experience to prove it. He's been thrown at many nearly disastrous projects that he miraculously pulled back together. He has sometimes been called "The Slasher" for the way he prioritizes the important parts of a project and cleanly cuts away anything unmanageable.

Thankfully, Kadono was also happy to accept the project. As a side note, Takeuchi made Kadono the assistant manager of Capcom's Production Studio 1 while he was at it. Takeuchi's selection of Kadono was yet another example of how cognizant Takeuchi was of the importance of project management. Kadono was a key person in the development of *RE7*, and we'll be discussing him in much more detail later.

Two producers were chosen.

One was Masachika Kawata. A figured that appeared earlier in this report, he's known for being the series producer of *Resident Evil*. He was given the role of budgeting, as well as maximizing advertising and sales. For a game presumed to sell in the millions in advance, a massive budget would be provided, and equivalent sales would, of course, be expected in return. Such a heavy responsibility could only be left to someone who's overseen *Resident Evil* for as long as Kawata has.

The other producer, who would mainly deal in international marketing as the promotion producer, is someone Takeuchi invited personally. He was Tsuyoshi Kanda.

Throughout his fourteen years of experience in sales for Capcom, six were spent under Capcom USA. With his constant search for ways to expand sales globally and his experience in both domestic and international sales, Takeuchi saw Kanda as a vital part of *RE7*'s success. But because his main fields are sales and marketing, he'll be discussed a bit later.

Now they had the owner, the director, the project manager, and the producers.

You may not know exactly what all these positions do, but they're best explained using Kawata's words:

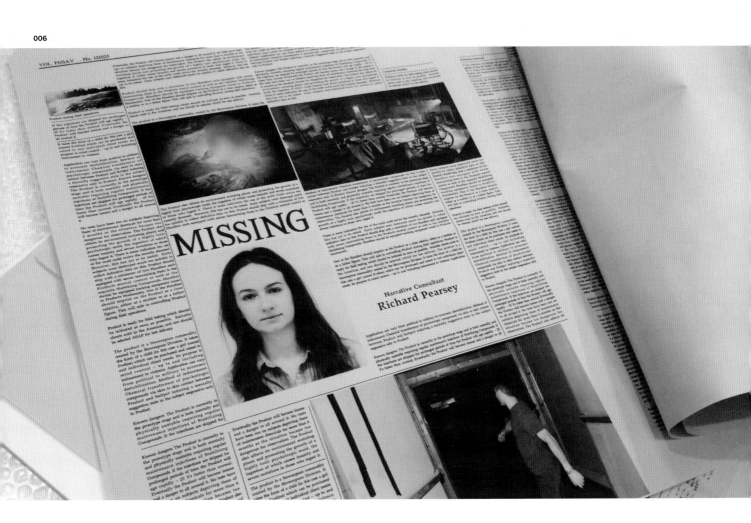

007

"If a game isn't good, it's the director's fault. If it isn't completed on time, it's the project manager's fault. If it doesn't sell, it's the producer's fault. And ultimately, all responsibility falls on the owner."

Also, as stated in the previous chapter, Takeuchi felt the need to construct a more efficient game development environment and develop the next generation of talent. He felt that the development of *RE7*, in particular, might be the culmination of his

work as a game creator. In which case, he wanted to leave as much to the next generation as possible.

To that end, one of his tests was the game engine.

The game engine would have a great effect on the development staff and their environment. Game hardware was ever-advancing and evolving, but making full use of a new console required long periods of

hardware research. To put it simply, the engine serves the purpose of optimizing the hardware and making it easy to work with. Most game makers use a user-friendly, general-purpose engine.

However, for the development of a game like *RE7*, Takeuchi thought a highly generic engine developed by another company may not be appropriate. Often, those engines aren't a good fit for the development of cutting-edge games.

006

Concept art of a newspaper article about someone who went missing around the Baker residence and the search for her. It's shown during the game's credits.

007

Concept art entitled "talisman." Talismans are objects indicating symbols or signs used in spells. Was this one created to protect the Baker family from trespassers? Or perhaps the opposite: to invite interested parties in?

For *RE7*'s development, a specialized engine was needed. It didn't need to be something another company could use, it just had to be for Capcom, and for future installments of the *Resident Evil* series.

Takeuchi had a theory about the development of new engines. When you're trying to develop something for use by many people, you seek the opinions of many people. But was that really right? An engine like that could only solve the most basic problems.

He thought an engine should be specialized to have a specific person's desired functions, such that it solves those particular issues well, and then leave it to the staff to use it. Such an engine is what Takeuchi wanted to make for *Resident Evil 7*. This engine would later become known as the *RE* Engine.

And so, by the end of February 2014, the initial team members, numbering less than ten people in total, were assembled, and the core of the team was complete.

The search for talent continued, prioritizing individuals who agreed with a wildly different development approach, or those who felt a special affinity for horror-focused games like *Resident Evil*. Teammates with the necessary skills, and the shared objectives and ideals, were located one by one.

INSIDE REPORT

IV

ONE MAN'S STANDARDS

With *RE7*'s members assembled, Takeuchi then wanted to get his image for how the team operated across. He got in front of the team and said the following:

"Simply put, I'm the hurdle. If I say it's good, it is. If I say it's not, it isn't. Don't concern yourself with what the company or anyone else says. First and foremost, I want you to do the job you're supposed to."

The statement came off as rough, but it was delivered with good reason. Most companies collect data about what the consumers think, how they feel, what they want, what the market's like, and so on. Nowadays, the internet has excessively expanded our ability to gather information. However, anything produced in response to that data is incapable of surpassing the consumers' expectations, because it's based on what they've already seen before.

Takeuchi had a similar thought to when he started development of the *RE* Engine. When someone tries to make something big, they seek many people's advice. However, that doesn't necessarily bring good results. He already had the core vision for *RE7* in his head. All he had to do was leave it to the staff to implement that vision.

In order to accurately communicate his core vision, Takeuchi poured his energy into sharing the concept of *RE7* with the team. He figured they could be left to work independently once they all soaked it in. If anyone on the team had a good idea, he wanted him or her to go through with it without fear of failure. After a trial and error process, he would order the team to fix anything that strayed from the concept. Taking the position of the one everyone else relied on, Takeuchi was truly the unshakable core. As long as they remembered the core, there was no need to think about the company or anything else. To carry it all out, Takeuchi made himself the judge of the project's standards.

And so, the first thing he had the newly formed team do was to create a concept movie. There were two objectives in mind. One was to use the production of the movie to solidify the concept for the team. The other was to use the finished movie to inform those outside the team of what type of *Resident Evil* they were trying to make.

Takeuchi's Production Studio 1 is one of the production studios set up at Capcom—but for them to begin production on anything, they needed various forms of approval from the business side. Naturally, they had

to get the business side to understand and approve the type of game they were going for. And once the, at this point, few dozen member *RE7* team began to really get to work, there'd be a significant expansion of scale. Having a movie, they could show future additions to the team allowed them to get the concept across faster.

The core staff members not only talked but, on some occasions, also went to popular haunted houses and ruins for research purposes.

It was when Nakanishi started asking other members to come and test their courage with him that Takeuchi began to get the feeling the project would go well. Every member of the team understood the concept and tried to expand it further. That was exactly the kind of development team Takeuchi wanted.

By this time, two years had passed since *Resident Evil 6* was released. Everyone had his or her own feelings about *Resident Evil* as a series and even stronger feelings about the game that would follow *RE6*. Those feelings flooded out like a dam had burst. As a side note, when members were asked what it was like at this time, everyone enjoyed talking about

008

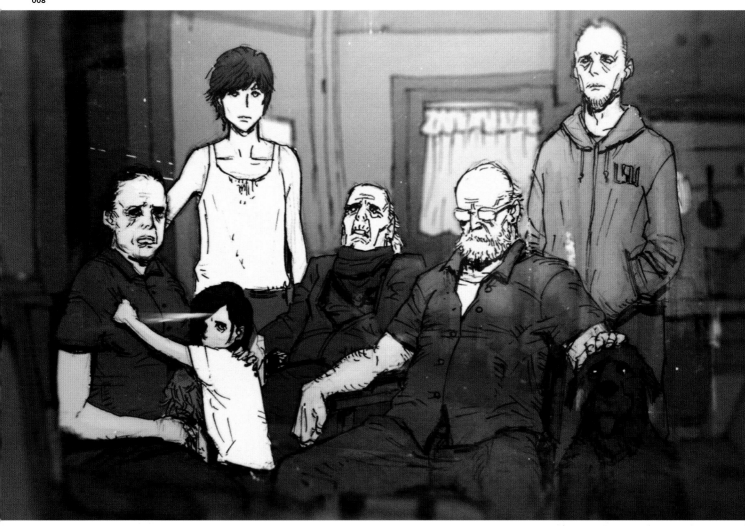

walking around ruins or other similar experiences.

The concept movie was finished in one month, specifically, at the end of March 2014. The movie featured wandering the narrow halls of an eerie house, ending with just one thing to scare the viewer. It was only three minutes long, but it was three minutes that the developers poured their souls into. Everyone on staff drew on Takeuchi's core vision to create this video that encapsulated a feeling of true horror.

If someone who played *Resident Evil 7: Beginning Hour*, the demo that was uploaded in June 2016, were to watch the

movie, they may find the layout of the house, the mood, and the atmosphere to be familiar. The concept movie was produced in March 2014, but *RE7*'s concept was set in place, even in the first stages of development. The concept, shared uniformly throughout the team, stood the test of time admirably.

But the business side's reaction to the movie was by no means unanimously praiseworthy. Some concerns and anxieties were readily evident. You could call it the expected response. After being shown a concept so different from the series' previous trajectory, it would be harder not to have some doubts.

008

Concept art of the Baker family. What appears to be a family of four: father Jack, mother Marguerite, eldest son Lucas, and eldest daughter Zoe. They, along with their grandmother, debut in the game almost exactly like this image.

Still, Takeuchi made the following points clear at the presentation. Online features weren't needed, nor was an open-world concept. The concept should be narrow, yet deep as possible. If they could make something truly frightening, the rest would come naturally. Wasn't that what the first *Resident Evil* was about? That was the real essence of the series.

Takeuchi's confidence may have convinced the business side. The project was approved and *RE7* proceeded to the next step.

009–011

A collection of sketches made while searching for the image of the terrifying family. Eerie twins, a hunting dog, and inhuman transformations were among the things drawn.

012

Character sketches. General characteristics and appearances are approaching their final versions. The top row features the news crew, Mia, and Ethan. The second row is the Baker family. Chris Redfield appears in the third row. The children in the fourth row may be connected to Eveline's character image.

009

010

011

012

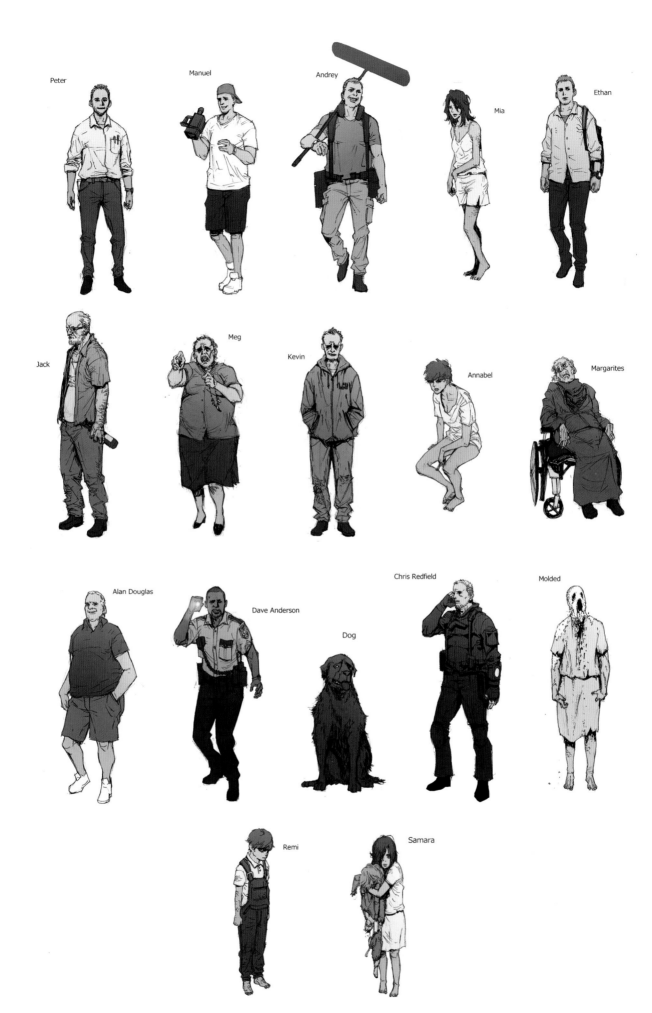

Peter

Manuel

Andrey

Mia

Ethan

Jack

Meg

Kevin

Annabel

Margarites

Alan Douglas

Dave Anderson

Dog

Chris Redfield

Molded

Remi

Samara

INSIDE REPORT

V

PROJECT MANAGEMENT

If January 4th, 2014, the day Takeuchi was called by Kenzo Tsujimoto, was the day *RE7* was born, it could be said that the project began to really advance in April of the same year. Once the concept movie was produced and approval from the business side was successfully acquired, the project assembled even more staff. With about fifty members, development got seriously underway.

The greater the scope of a game's development, the more members and the longer a schedule there is to manage, making a project manager vital. The team's operations depend on the manager's skill. At the time, in April, the aforementioned Makoto Kadono was the only project manager, but the *RE7* development team would later set up an organization called the PMO (Project Management Office). The many project managers in the PMO would manage the schedule and the staff members. The PMO was held together, of course, by Kadono.

I'd like to take this time to talk more about Kadono. He joined Capcom as a programmer about twenty years ago. He's been involved with the development of many games since then. As gaming hardware performance increased over the years and the scope of game development expanded

along with it, he foresaw the arrival of numerous problems. He quickly realized the important role project management would play in solving those problems, learned how to do it, and tried different approaches to see what worked. He's managed a variety of different projects since 2008, putting him in a position of experience.

Now, what type of problems did the growing scope of game development bring?

Generally speaking, it's easy for things to get chaotic in the final stages of production whenever you're creating anything. When a long time is spent working on one product, the creator may begin to question whether that product is any good. That is especially true for game development, a process that takes years. As the deadline approaches, everyone pushes their bodies and minds to the limit to try and improve the game. But there isn't much time left. Someone may want to add an element, or cut another, but would it really improve the game or be worth the effort? With nobody around to say no and everyone trying to put in everything they can at the last second, projects get messy.

On one large scale project that Kadono programmed for, he was given the position

of project manager right at the end of production. The chaos of that project couldn't ultimately be contained, but he did somehow see it through to completion, and the game ended up being a big success. Following that project, Kadono took the role of project fixer on a number of games that went off the rails.

The main roles of a project manager are to consider the workload, required time, and importance of every part of the project and to reposition staff members as the situation calls for it. Kadono organized every task by order of priority, and if things didn't go as planned, he would mercilessly cut even wonderful ideas. Then he would relocate staff to more important, effective parts of the game.

Takeuchi knew that a project management expert like Kadono was indispensable for the development of a huge game like *Resident Evil 7*. As such, during the gathering of the core members, he went straight to Kadono and put him in as the assistant manager of Production Studio 1.

So, how did this project actually go under Kadono's management? Considering how long it took after the release of *RE6* (four years at the time of this writing), many may

013

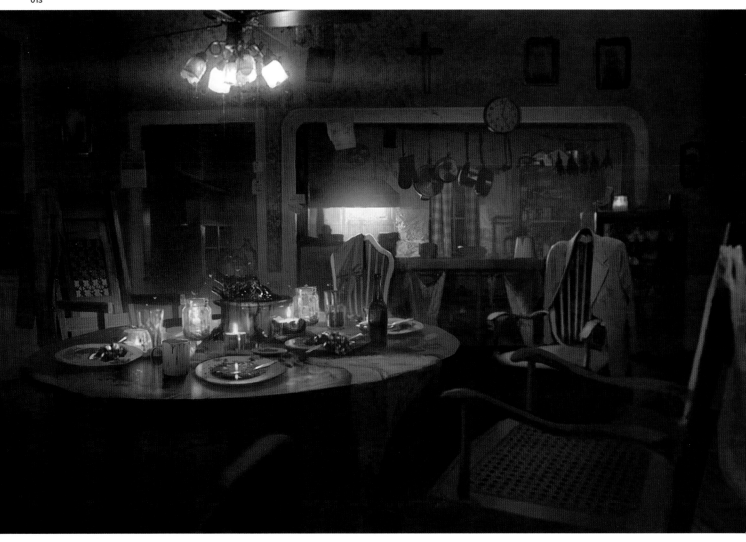

assume there were complications. The truth is, up until Tsujimoto asked Takeuchi to take on the project, it was most certainly rough.

But when the present *RE7* development team really got to work, the beta (a version of the game with the main components complete) was finished in only two and a half years. Not only that, but they created a whole new engine for it, and incorporated technologies and methods they'd never used before. While taking on these challenging tasks, they put together a game

worthy of being a numbered *Resident Evil* title within the limited development period.

RE7 went in a considerably different direction and had a very distinct concept from the previous game. It was also the first time Production Studio 1 developed a Triple-A game for next-generation hardware. That's a new concept, new hardware, a new engine, and a new team. It's said that most projects where more than one of these things is new don't end well. But the *RE7* development team pulled it off.

013

The dining table in the main house. It's unsure if they have finished their meal or are just beginning. Some kind of dark mass has been thrown into the pot in the center.

Of course, that wasn't merely Kadono's accomplishment, but it should be made known that everyone on the team, especially Kawata the producer and budget manager, would agree that Kadono was very important to the final result.

Now how, exactly, did the *RE7* development team proceed through the development process? In the next chapter, I'd like to describe how the production of this game was organized.

014

A shot of Zoe inside the trailer in the yard. Her expression reads of fear, exhaustion, and anxiety, showing that this was taken after her family's transformation. Interactions with Zoe in the game are few, so this is a very rare piece.

014

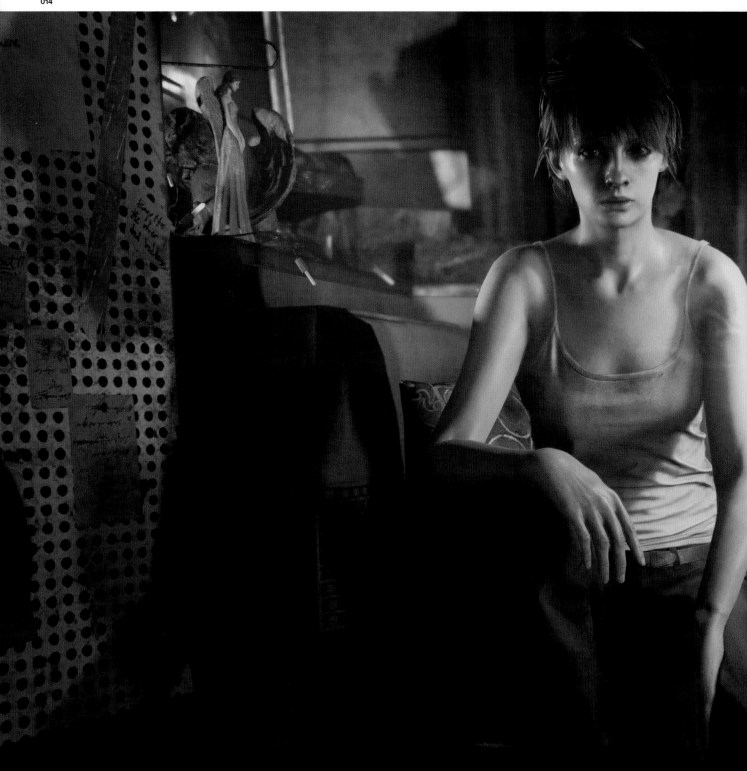

015

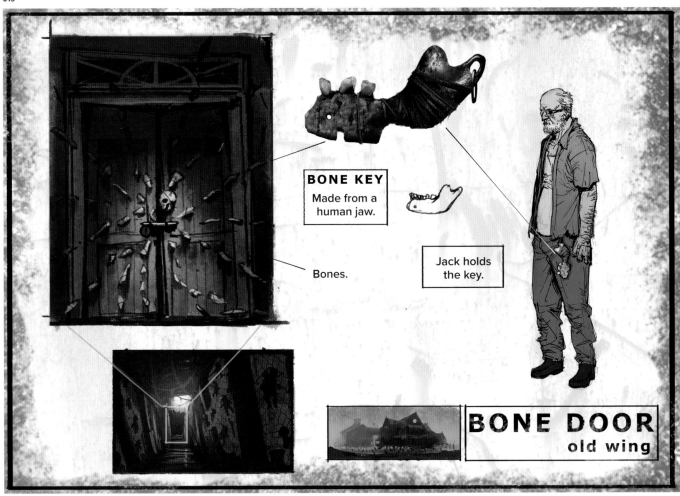

BONE KEY
Made from a human jaw.

Bones.

Jack holds the key.

BONE DOOR
old wing

016

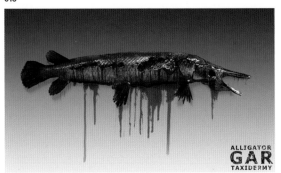

ALLIGATOR
GAR
TAXIDERMY

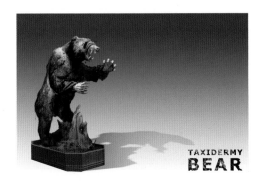

TAXIDERMY
BEAR

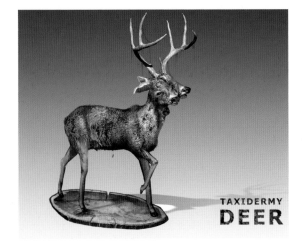

TAXIDERMY
DEER

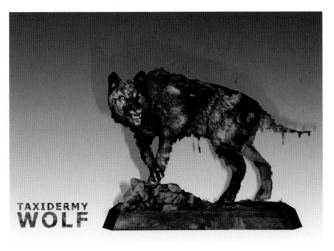

TAXIDERMY
WOLF

017

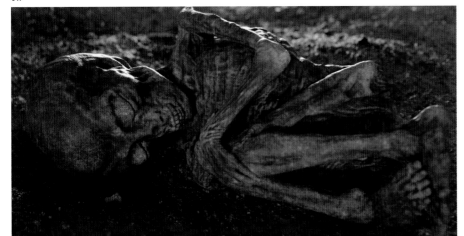

015
Jack with a key made of human bones.

016
Mounted animals and fish to embellish the Bakers' home. A garfish, bear, deer, and wolf.

017
A mysterious, mummified specimen. Could it be the model of a child mummy found on the altar?

018–020
Themed doors and keys placed at important points around the Baker residence. From the top: crows, scorpions, and snakes.

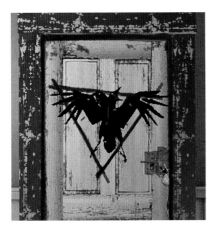

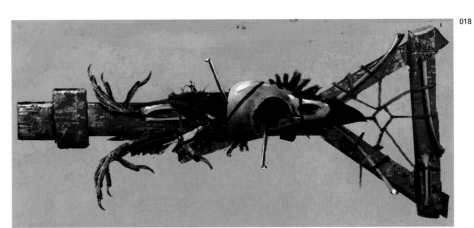

018

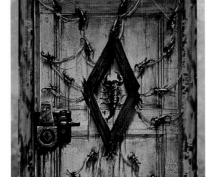

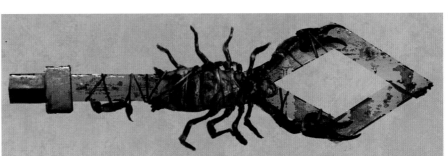

019

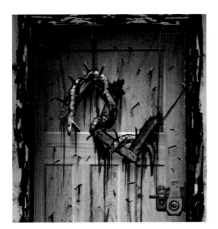

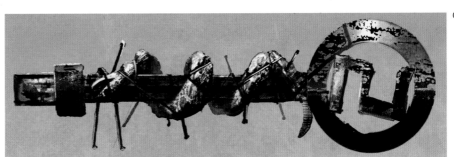

020

INSIDE REPORT

VI

RESIDENT EVIL 7'S DEVELOPMENT APPROACH

When you hear about video game development, many may think of a team-centered around a director or producer, with planners, programmers, designers, and other positions organized in a hierarchical order.

However, the *RE7* development team used what they dubbed a line structure. Rather than divide members up into a programming team or a design team or so forth, they could be split up, for example, into a level design line, a background asset production line, and a character production line. A character production line would create the human and creature models, animations, associated sounds, and everything else necessary for character production. The level design line would be in charge of where creatures, items, gimmicks, and so on would be located in the game itself.

No line could function with just programmers or just designers. Producing character models would be left to the designers, but the animations and sound effects required the assistance of another staff member. As such, each line contained a mix of planners, programmers, and designers. Also, these lines would, depending on the phase of development, readily split, merge, or change members, forming "squads" or "groups."

To understand what makes this approach fascinating, you first need to understand how the game development environment has transformed over time. I'll be using some more technical terms, but bear with me—once you understand the ins and outs of game development, it's all very interesting.

The producer or director proposes the game they want to make.

Each team leader decides on a game system and creates the framework.

The planners fill in the details.

The programmers, designers, and such produce the individual parts.

This may be what you imagine the steps of video game development to generally be. This is what's called the waterfall model. Once it's clear what they want to make and the people at the top have settled on the details, the job is shifted over to the next level down, like water pouring down a waterfall. This is a traditional, even orthodox development approach. One benefit of this is that the work is done in a set order, so the project's progress is easy to follow.

However, this approach also has a weakness. If the game as planned at the start of the project proves to be lacking, or if there's a big shift in direction mid-development, the strictly regimented nature of this method would mean much of the work goes to waste or a lot of time needs to be spent fixing it. Major changes during the development process aren't uncommon, especially in the realm of game development, where it's hard to know if the product is good until it can actually be played. This is even truer now that the scope and length of projects are greater than ever before.

Due to the waterfall model's lack of flexibility in handling the amount of time it takes to check functionality and the resulting changes in plans, using it becomes more of a risk the bigger a project gets. As a response to these issues in software development, we saw the creation of agile software development and a variety of that known as "Scrum."

First, agile software development describes a set of approaches to swiftly and flexibly developing software.

Most agile software development methods aren't about deciding everything in detail, but getting the project started with the

general approach in mind. It's also unique in that it splits the project into parts and sets up short periods of time called iterations in which to develop those individual segments one by one.

The software would ultimately be completed after a series of these iterations. The game isn't planned and created all at once, but divided into several deadlines with incremental goals to be set, designed, implemented, tested, and sometimes revised before moving to the next increment. Alterations to the plan or approach are assumed to occur in advance and new ideas can be picked up mid-development,

so this can be considered a development approach that's receptive to change. However, compared to the waterfall model, it's difficult to get a complete grasp of how far the project has come along.

Scrum is one type of agile software development.

The word scrum might make you think of rugby in that it refers to the team huddling together, and it takes the same meaning here.

In the Scrum model, first the guide, or Product Owner, who decides the direction of

021

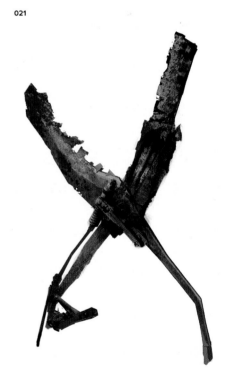

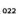

022

the product (in this case, this duty goes to the director, Nakanishi) acts as the project's center and produces a list of what functions to implement or what to change. The team spends two to four weeks implementing items from the list. This period of time is called a "Sprint," and during a Sprint, there are short, daily meetings where everyone reports yesterday's accomplishments, today's goals, and their current issues. After a series of these Sprints, the product is completed.

This Scrum model was initially implemented for the development of RE7.

As stated previously, Takeuchi was fixated on making sure every member of the team fully understood the concept and goal. And after the concept was thoroughly soaked up by everyone, he hoped for an environment where the staff could independently propose what they wanted to do. The

Scrum model, where every team member constantly acknowledged, shared, and solved their problems, was the perfect fit.

Every morning at 9:30, the RE7 development team split up onto different floors and held meetings where everyone checked in on each other's progress, as well as quickly sharing their problems. Problems were dealt with in units of days or weeks before new ones were tackled. Over the course of the short cycles of planning, implementation, testing, and revision, the team soaked up the concept, and many ideas were proposed, considered, and tried out. It all went as Takeuchi planned.

By the way, there's a reason I said they "initially" implemented the Scrum model. Partway through the game's development, they did switch to the more traditional waterfall model.

Yes, the RE7 development team used both the Scrum and waterfall models. During the beginning to middle stages of the project, when the vision and concept were being solidified and staff members independently tried things they wanted to do, trial and error were expected, so the highly flexible Scrum model was used. Following that period, in the late stages of the project, when they knew what they wanted to do and needed to put it all together into a product, the more easily paced and managed waterfall model was followed.

Of course, this was easier said than done. But in just two and a half years, a shockingly short development cycle for a Triple-A game, they had a complete product without sacrificing any quality. That wouldn't have been possible without Takeuchi's leadership, the core team members like project manager Kadono and Nakanishi (who never failed to unite the team under the game concept), experienced game development

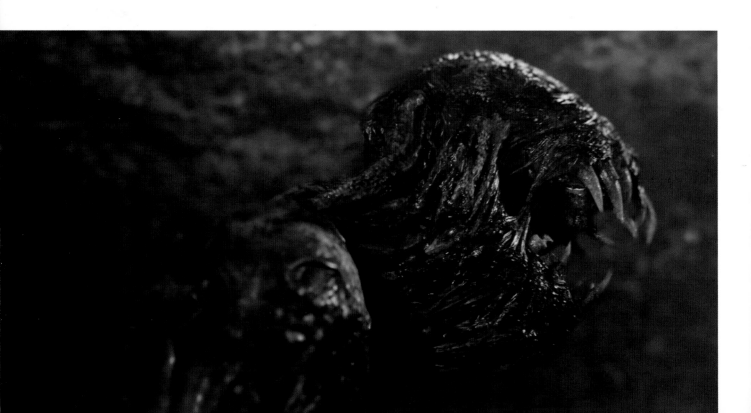

veterans, and the hard work and ingenuity of their likeminded development staff.

Additionally, the line structure I mentioned at the beginning is something that was created during the move to the waterfall model. In order to explain those details, I will need to explain the features of the *RE* Engine, which is closely associated with the line structure. That can be left for a later chapter.

As a side note, from the perspective of a writer of a report like this, you do hope, albeit not maliciously, that there are peaks and valleys in the development process. So, at times when you would expect problems to arise, such as just prior to the completion of the beta, I asked about the game progress. But in response, Kawata told me the following more than a couple times.

"Sorry, development's proceeding smoother than expected."

023

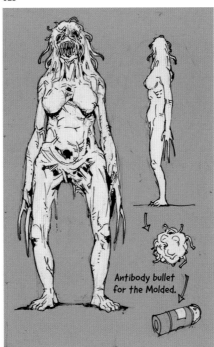

Antibody bullet for the Molded.

024

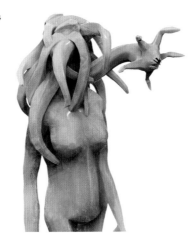

025

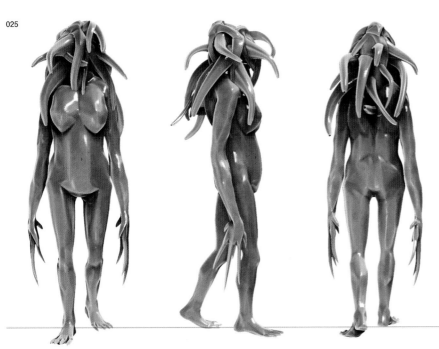

021
Giant shears used by Jack in the morgue.

022
Designs of the statuettes used for the projectors in the Baker residence.

023–026
Design proposal for a creature. It has the image of fungal filaments and is considered to be the prototype for the Molded.

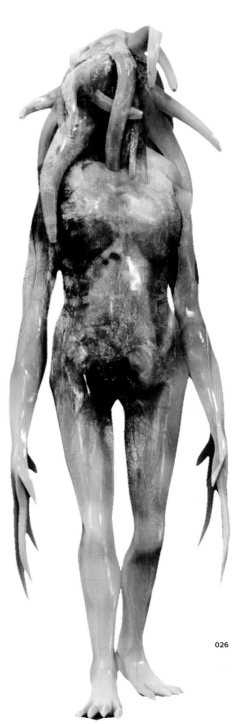

026

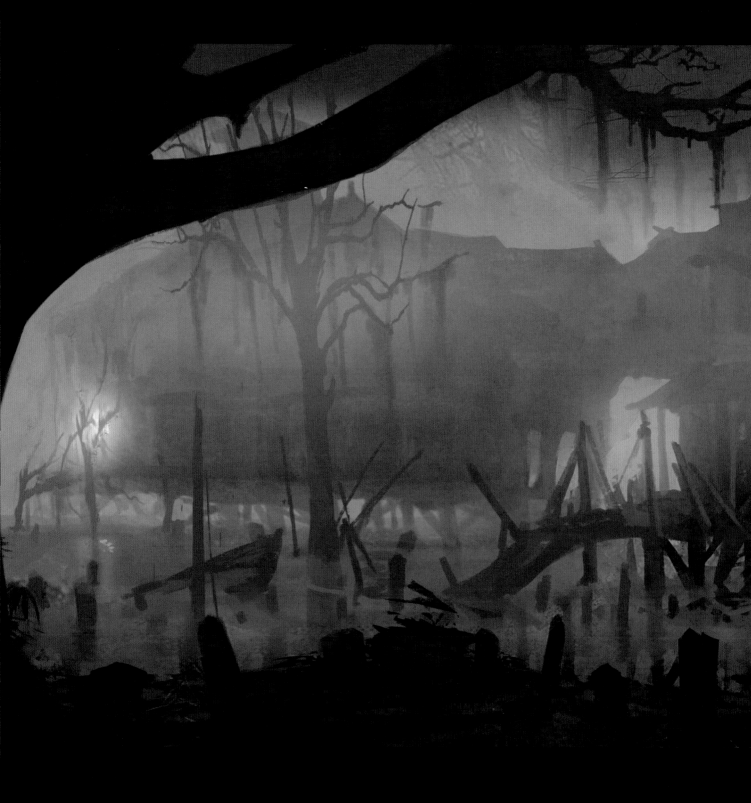

COLUMN II: MOLD ADAPTS TO ALL ENVIRONMENTS

TEXT: DENGEKI STRATEGY GUIDE EDITORIAL DEPARTMENT

The proliferation rate of mold is remarkable. If the environment is optimal for propagation, it has enough reproductive power to turn a surface completely white with mycelia in the blink of an eye. For example, when cultivating mushrooms, it's good to use sawdust sterilized at a high temperature and high pressure and cooled leaf mold as a growth medium. It's also advised to plant a few spores and grow them at around 30 degrees. Since there is nothing to hinder breeding in sterilized growth mediums, the sawdust should turn completely white. Raising and lowering temperatures or utilizing electric currents to grow the fruiting body (mushroom) is considered "mushroom cultivation." In a bad environment, however, the mold's growth is slow. At times like those, mold conceals itself in the culture medium when hyphae are slightly emerging from spores. And, when the environment is compatible, propagation starts explosively.

Mold adapts to every conceivable environment. To name a few familiar places, the slime in your bathtub is mold, as is what lurks

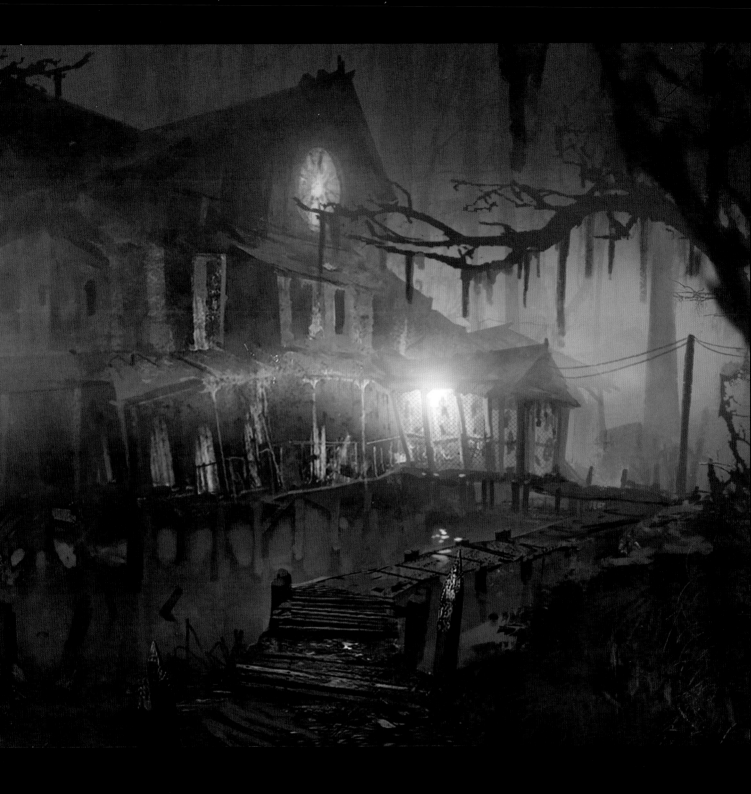

between the joints of mechanical seals and tiles. Such mold penetrates deep into tile joints, spores spreading to the corners, so even if sterilized and disinfected with a chlorine-based mold spray, it recovers quickly—maybe in just a few months. (Hasn't everyone experienced this?) Controlling mold with chemicals is no easy feat, so it's important to know that it's nothing more than a coping mechanism. But mold is also a living thing. It's weak to boiling water and, of course, fire. Just by applying high temperatures, mold can be rooted out from even tile corners. A majority of molds are also

susceptible to dryness and sunlight. In actuality, the places where mold and mushrooms can grow are mostly moist and humid spaces. Those that can withstand dryness are but a small fraction, and their reproductive power is exceedingly low. Furthermore, it's possible to suppress their biological activity by using antifungal agents to pick off specific molds.

INSIDE REPORT

VII

THE REAL START OF *RESIDENT EVIL 7*

Chapters 5 and 6 focused on some technical matters, so now I'd like to look at the flow of development. Please bear with me; I'll be dealing with a few technical terms this time as well.

Takeuchi took charge of *RE7*'s development in January 2014. From then to spring, he gathered the core members of the team and created a concept movie. The objective was to use the movie to share Takeuchi's ideal concept of a narrow, deep, horror-focused *Resident Evil* with the entire team.

After the concept movie was completed, the *RE* development team was expanded to about fifty members and the project really began. First, they decided on the goal they wanted to reach in one year's time, the completion of a "vertical slice." A vertical slice is a completed segment of a part of a game (often the first stage) with all the features implemented and near-final product quality. The appearance and control of the vertical slice is nearly the same as the final game, but only one part of it. After that, the game's full production schedule can be made more accurately, allowing for more efficient development progress.

To complete the vertical slice, the development team split into three teams:

• Prototype Creation

• Art Creation

• RE Engine Creation

Then they began production.

The prototype creation team's main objective was the production of a "gray box." Then, for the next stage, they wanted to use the gray box as a basis for creating the vertical slice. (At this time, the team would be partially rearranged.)

Much like vertical slice, gray box is a term only developers are likely to have heard. Also related to software prototypes, a gray box is a prototype that gives you a full perspective on a game and its properties. This is a test version that leaves the graphics for later, rather focusing on making the general flow, gameplay, and concept understood.

Production of the gray box would use a pre-existing game engine called Unity. The creation of an all-new *Resident Evil* would demand coming up with a variety of ideas, then implementing and testing them. A general-purpose engine like Unity was a perfect fit for the purpose of the gray box,

which required no advanced graphics and expected to see frequent changes.

The art creation team had to consider what kind of world to construct, what creatures and backdrops should populate it, and then it had to create that world. This would involve not only design and data creation but also the unification of writing methods with all kinds of graphic data production concepts, solidifying their development process.

The third team was the *RE* Engine creation team. As previously stated, Takeuchi wanted to create a game engine specialized in doing what he desired for the game, as well as remain useful throughout the next generation of games. For that purpose, when *RE7* development fully began, the development of a new engine began alongside it.

Essentially, the *RE7* development team's goal was to spend one year using Unity to create a gray box, then switch to the *RE* Engine partway through and create a vertical slice, implementing graphics and functions on a level near what one would find in the final product. Of course, there'd be twists and turns on the way, but I'd like to save details on that for future chapters.

RE7's development was just getting under-way, but Takeuchi had some concerns. He wasn't sure whether the development team would go along with his plan to create a *Resident Evil* that differed so drastically from its predecessors.

However, contrary to his expectations, most of the staff agreed with his ideas, and the teams began to take form.

Tomonori Takano was one of the team members who joined in the spring of 2014. He was one of the art directors on *RE7*, and a key person to discuss in regards to its development.

Takano was an art director on *RE6* as well. That game had garnered huge sales worldwide, but it left him with regrets. *RE6* tried to respond to all of the fan's wishes by using numerous characters in varied situations. With four main scenarios, the game was massive and the staff worked tirelessly on it. However, as one of its developers, Takano couldn't help but think there might have been a better way to go.

To Takano, Takeuchi's direction for *RE7* was like divine guidance. Forget about the past, whether people have a problem with it or not. Just because it's a numbered game doesn't mean it has to be shackled down by previous *Resident Evil* games.

"There's no need to worry about what anyone else tells you; it's good if I say it is."

In addition to the above, Takeuchi also told the development staff the following.

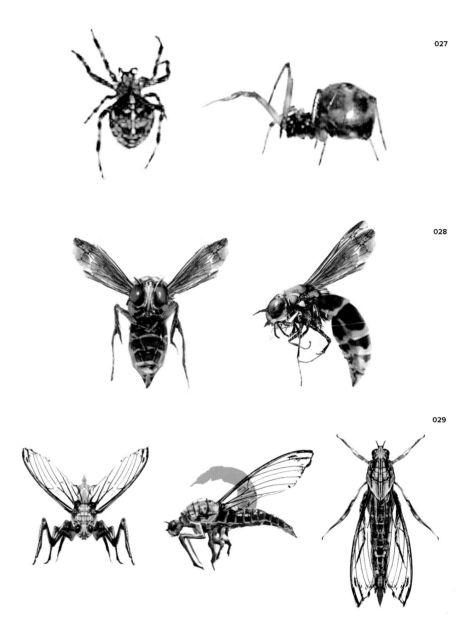

027

028

029

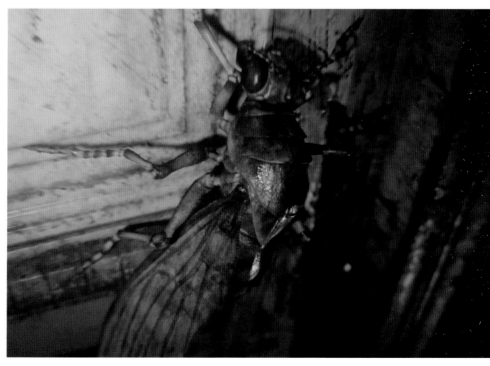

"As long as it's good, they'll accept anything. To make sure it's good, we'll leave time for trial and error. There's no need to be held back by past games. This is to be the ultimate horror game. As long as you don't stray from that concept, you can do as you like. Try new things."

Takano was delighted and, only three days after joining the team, he produced an art guide forming the basis of the art design in *RE7*.

Thus, from spring to summer of 2014, many ideas were put forth, and much was implemented and tested. During this period in particular, the previously described Scrum model proved extremely effective. As a model in which what had to be done was made clear with one proposal at a time—and individual problems were shared in short, periodic intervals—Scrum was ideal for trial and error.

Another fascinating detail is that, at this time, *RE7* didn't have a concrete story. When a game's story is written in advance, trying to construct the game around it can have unfortunate results. It's appropriate for some projects, but *RE7* was intended to be the ultimate horror game. Making the game scary and entertaining came first, so the story could be left for later. One might think art design would be impossible without a story and associated setting, but thanks to the development team's deep understanding of the game concept, it wasn't much of an obstacle.

Of course, there were droves of ideas that went unused.

For example, an idea that came up around this time was to have the player's left and right arms be individually controlled. They already decided early in the process to use the first-person perspective, later dubbed "Isolated View." From a first-person

perspective, the player could only see their hands. Allowing those hands to be moved independently of each other could potentially add a new level to the gameplay.

Personally, I thought it was an interesting idea when I heard it myself. You could, for example, hold back an enemy with your left hand while you shoot it with a handgun with your right.

But in the end, it wasn't implemented. It was partially due to the amount of work and technical complications, but most importantly, it didn't fit well with the concept. It should go without saying that more familiar controls would make the game easier to play, and presenting a unique type of control wasn't the goal for *RE7*.

Another suggestion was to implement sliding. Another was a hide and seek-like system where you had no idea where the

030

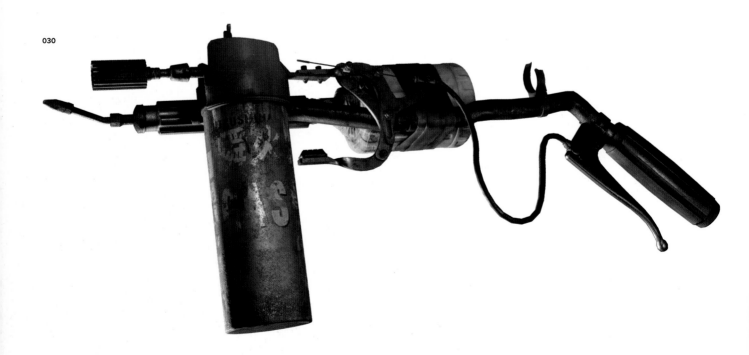

enemies were. Another was that having a massive number of enemies, even if limited in type, attack at once may be scary.

All these ideas were scrapped too.

"When you're trying to create something new, people always want to make it bigger and flashier."

These are Takeuchi's words. He didn't want it to become an action game that was nothing but show, and he didn't want lose sight of the essence of horror. If the team would stray from the path, Takeuchi, as the one in charge, didn't hesitate to stop them.

Takeuchi's way of thinking could also be flexible if necessary. For example, at first, he wanted to pursue the "narrow but deep" concept by having only an extremely limited number of enemies. But during the trial and error process, it was found that the game was lacking as a result, so they immediately sought to fix it.

There were also times when they hit a big wall.

At the end of the summer of that year, the prototype creation team finished Chapter 1 of the gray box. As I explained before, a gray box is a prototype that leaves the graphics for later and just tries to get across what the game is like. But what had been completed at this point was only one part of that.

However, at this time, Chapter 1 was simply not interesting.

They made it according to plan, and it wasn't good. This happens in the development of many games.

On *RE7* though, the team had a good idea of their final goal in mind. They knew from the start what the game ultimately needed to have and what elements might be shaky, so even the walls they ran into were expected.

Takeuchi referred to these as "logical worries." It's the nature of modern game development to have a clear goal from the start and head towards it. No game is created without some failures. The true failure would be to not expect problems in advance. They just needed to test one theory, then another, until they found the answer.

New ideas were soon added to Chapter 1, and it was redone. With the exception of a few bumps in the road, *RE7*'s development proceeded smoothly for the rest of 2014.

027–029
Designs for the flesh-eating spiders and insects nesting in or flying about the old house.

030
A hastily made spray-can burner.

031
The homes of those nesting in the old house look like beehives or spiderwebs. When set aflame by the burner, the residing insects fly out in swarms.

031

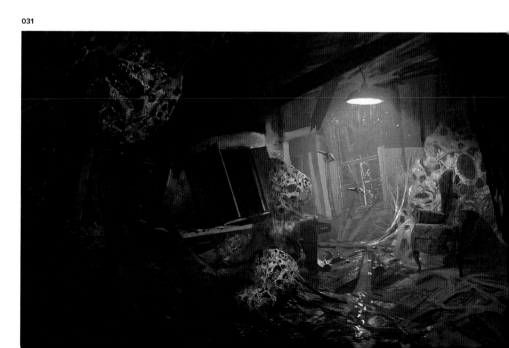

It was also at this time that the art and *RE* Engine creation teams made advancements in the development of technology that would be important to the production of *RE7*.

In addition to the *RE* Engine, there was also photogrammetry and VR. I'd like to touch on one of those, photogrammetry, in the next chapter.

032
A spider-like transformation.

033
Mother's transformation. A bug-like leg attempts to crawl out from inside.

034
It strikes out from a corner of the old house's greenhouse. Is she the bug queen or their nest? Her form changed, she's no longer human.

032

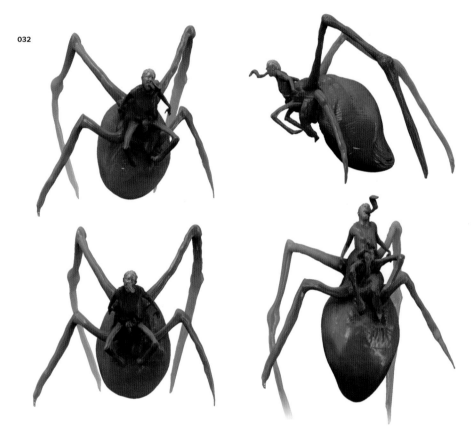

033

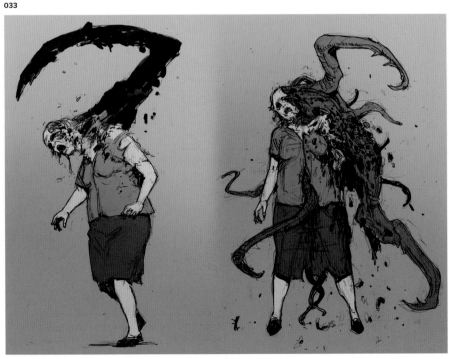

034

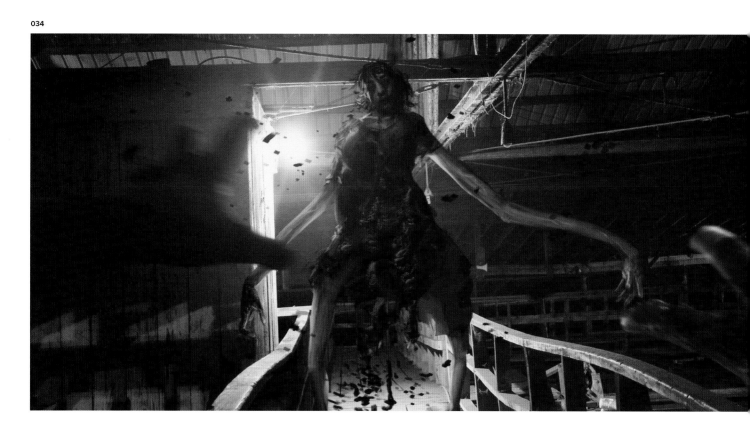

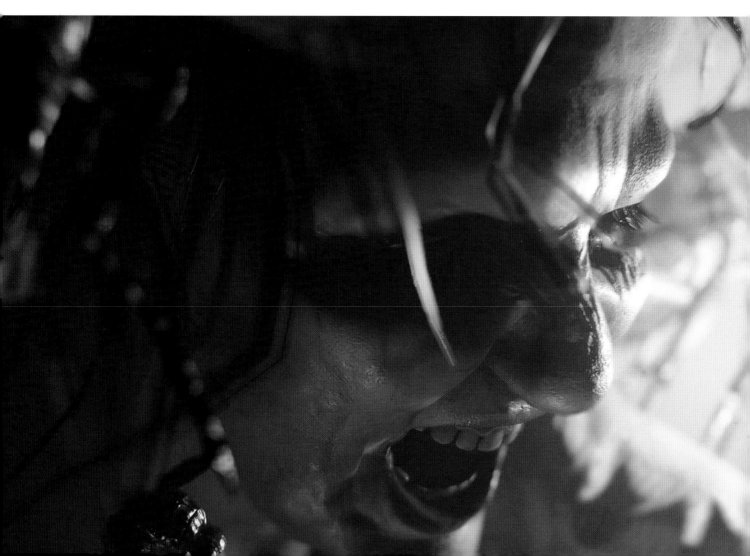

INSIDE REPORT

VIII
PHOTOGRAMMETRY

Have you heard of an event called CEDEC (Computer Entertainment Developer's Conference)? Put on by the Computer Entertainment Supplier's Association (CESA), it's the largest event for technology targeted at game developers in Japan. Every year, many game creators congregate for demonstrations and exchanges about various technologies. The event has contributed much to the advancement of Japan's game development.

In August 2016, at the CEDEC, the *RE7* development team held a demonstration that was widely discussed by game creators. It was titled "*Resident Evil 7 – Photogrammetry,*" and it was about the technology known as photogrammetry. A game creator friend of mine who happened to hear the demonstration was so excited that he was practically gushing about it.

He said, "In the future, when we discuss the history of Japan's big game releases, we might need to divide it into 'Before' and 'After' *Resident Evil 7.*"

First, I'd like to mention that photogrammetry itself isn't a new technology, and has in fact been used in many games already. Considering that, you may wonder what made veteran game creators speak so highly of this demonstration.

I think many of you already know how 3D objects in a game are created. Simply put, you first use 3D modeling software to put some polygons together and create an object. Then you finish by covering that object in an image called a texture.

However, while it's easy enough to model simple objects like dice, making something with a lot of curves out of polygons—like a human being—used to take a significant amount of work. And to make matters more complicated, game hardware has been constantly advancing. Compared to the past, far more polygons can now be displayed at once, allowing for many realistic 3D objects to be presented.

That means that the work involved in producing 3D objects has become an order of greater magnitude as well. Of course, technology for efficiently making high-quality 3D objects has also made progress over the years, but the work demand is still constantly rising. Think about an open-world game. It shouldn't be hard to imagine how great an undertaking it is to create tens of thousands of square meters of a realistic world by hand.

That's where photogrammetry comes in. Essentially, by taking photographs from multiple angles, it allows us to create a 3D object, complete with a texture.

For example, let's say you use a plane or something to take photos from above. By putting those through special software, you can easily turn a vast field into a 3D object. Because they are based on a real subject, the textures are, of course, realistic, and with the use of different perspectives, the rises and drops in mountains or valleys can be perfectly recreated. This technology was originally used in fields such as architecture and cartography.

There were game creators at Capcom who took interest in photogrammetry from early on. This happened before the development of *RE7* began.

Let's look back to 2013. At the time, Capcom's designers were worried about the yearly increase in the amount of work needed to create 3D objects. For example, the development of *RE6*, a game for the PS3/Xbox 360 generation of consoles, had numerous excellent designers involved. However, the workload was so massive that the design team could tell they were reaching their limit.

035

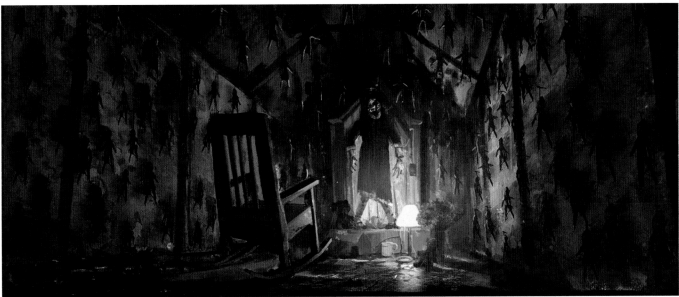

Time passed and game hardware entered the PS4/Xbox One generation, introducing a demand for even more high-quality graphics. Looking forward to the follow-up to *RE6*, game creators were naturally worried they wouldn't be able to create the game using the same methods they used on *RE6*.

They looked to photogrammetry as one possible solution. Interestingly enough, they didn't research the technology because the company ordered them to. Capcom employees who felt photogrammetry might be necessary naturally came together and looked into it on their own.

"Maybe you could call us the Photogrammetry Fan Club," said one member of the *RE7* development team, technical artist Makoto Fukui. A Capcom employee for twenty years, he's a veteran designer.

They researched photogrammetry on the side while doing their usual work. Their first test was simple. They put shoes, clothes, or whatever else on a turntable, pointed cameras straight ahead, a little high, and a little low, took photographs, and fed those into the software as a set. They were shocked when they saw the resulting 3D object. It was of greater quality than they imagined.

They also tried using a human subject. They couldn't use the turntable in this case. Instead, everyone used their digital cameras or smartphones to photograph the subject at once.

Again, the 3D object it produced was of unexpectedly high quality. They began to think they might be able to rely on this technology in the future.

Then, in January 2014, development began on *RE7*. For the sake of its completion, Takeuchi made the following demands of the art creation team (including Fukui):

• Have a shorter development cycle than ever before.

035
Concept art entitled "EvelynDoll." Do the dolls adorning the wall symbolize "friends" or "family"?

036
Around 150 high-resolution cameras were set up to gather photogrammetry materials. They can record and replicate details of the chosen object from all angles. Various props and characters with special makeup appear in the game

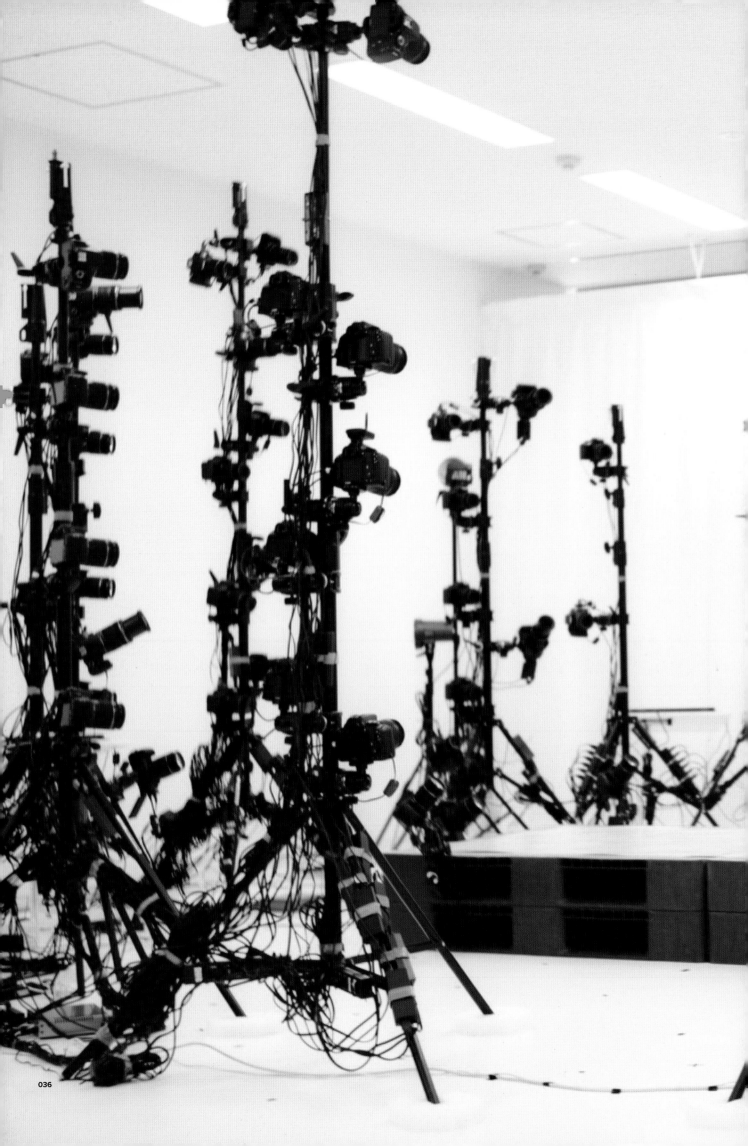

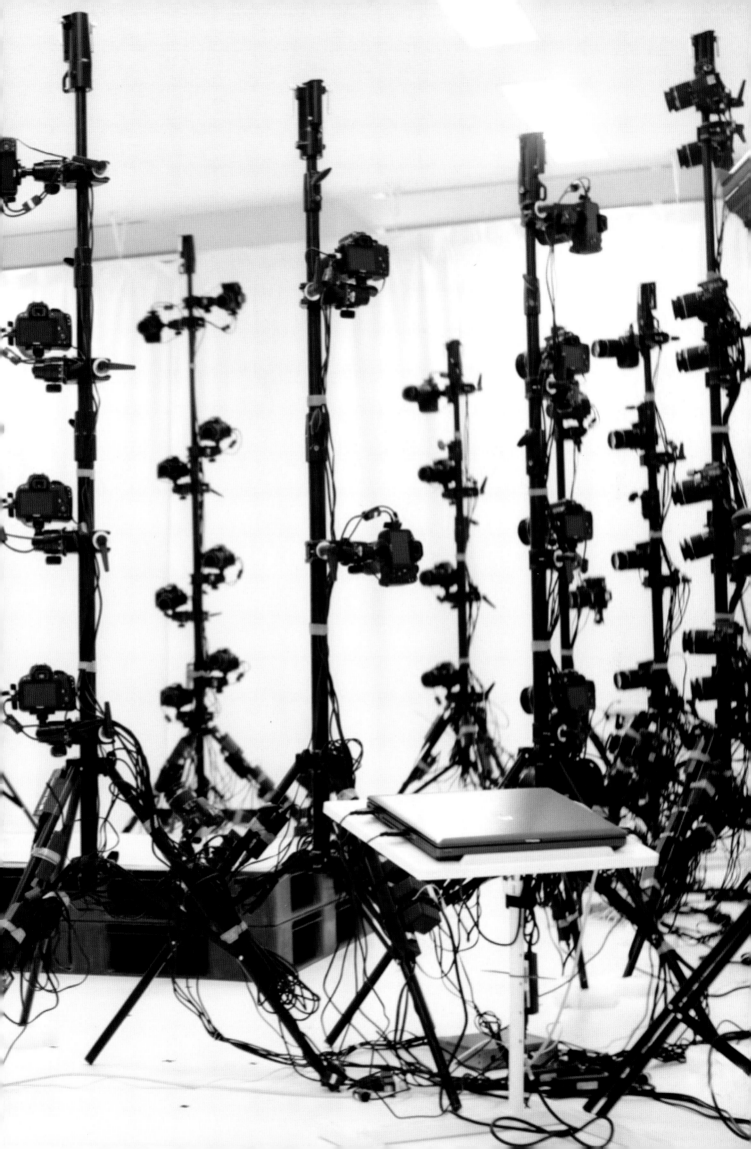

• Use fewer human resources than ever before.

• Have more assets than ever before.

• Have more photorealistic graphics than ever before.

Any reasonable person can see that these demands are absurd. To have a shorter development period with fewer staff members, yet produce more assets of higher quality is easier said than done. As mentioned at the CEDEC demonstration, the design team thought Takeuchi was nuts, an impression that became a bit of a topic online.

However, the demand certainly wasn't unexpected, and in fact, they already had a plan. Fukui and the rest of the design team proposed an idea to Takeuchi:

"We might be able to meet your demands if we use photogrammetry."

The first thing they did after getting Takeuchi's permission was gather information.

They talked to a company from abroad that specializes in photogrammetry and sent two staff members over to observe their way of doing things. The company's ability to make even detailed character models simply by scanning a human subject confirmed what they already believed, that by creating 3D objects with photogrammetry, they could make far higher-quality graphics than predicted in a short time. Fulfilling Takeuchi's orders would take a dramatic change in productivity. This technology was indispensable for the development of *RE7*.

With photogrammetry, it wasn't just human bodies and clothes that could be captured but also faces and facial expressions down to pores and skin texture. Fukui and the "Photogrammetry Fan Club" thought it could be used to meet *RE7*'s needs and efficiently create characters worthy of next-generation hardware.

One could say this solution was only reached because this is the *Resident Evil* series. On *RE7*, they were asked to create photorealistic characters. This was the

perfect environment for a technology that produces 3D objects from photographs. Were it a game where they were going for a more anime or cartoonish style, photogrammetry certainly wouldn't be ideal.

While *Resident Evil* also features non-human creatures, most characters are essentially humanoid. With the proper makeup for the models they were photographing, they could create not only the protagonist but the creatures as well. Of course, the design team didn't know how to use special effects makeup. But all they had to do was consult with specialists or study on their own. The staff members tried applying makeup to each other as a test. It went as well as they hoped, so next, they asked a makeup specialist for help and created the creatures.

As a side note, when I heard this story, there was a question on my mind . . .

With photogrammetry, all you'd need to do is learn this one piece of technology and you could easily produce 3D objects with-

037

038

039

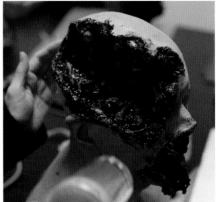

out the need for designers. (Although, it's not so simple in reality.) Designing terrifying creatures yourself and modeling them in a program is one thing, but using makeup to create creatures was a huge departure from the traditional job of a video game designer. In other words, the design team was testing a technology that could result in them losing their jobs, or alternatively give them even more work, but in a different field.

It may have been safer for them to tell Takeuchi his demand was clearly unreasonable and do their job as they always did. So why didn't they hesitate?

"Finding something new is extremely difficult, but learning something new is effectively simple, and most of all, fun," Fukui answered.

From what I gathered, Fukui didn't even hesitate for a second. It was simply something he had to take on. To him, that's all there was to it.

This is off-topic, but in my interviews with other members of the *RE7* development team, I had similar impressions on multiple occasions. They were willing to jump into new fields as necessary, and they had the spirit of a professional artisan pushing them to the limit to meet demands. That is, perhaps, the essence of what's kept Capcom at the forefront of game development.

Now, back on topic.

The design team had now determined the possibilities lying in photogrammetry, but what they needed was a studio where the

037–040
A depiction of a cracked skull with seemingly rotting flesh. We can't crack open an actual body, so we have to make one. Photogrammetry's true value lies in its ability to utilize the strength of raw things, a traditional cinematic approach, and digital strengths to their full potential.

040

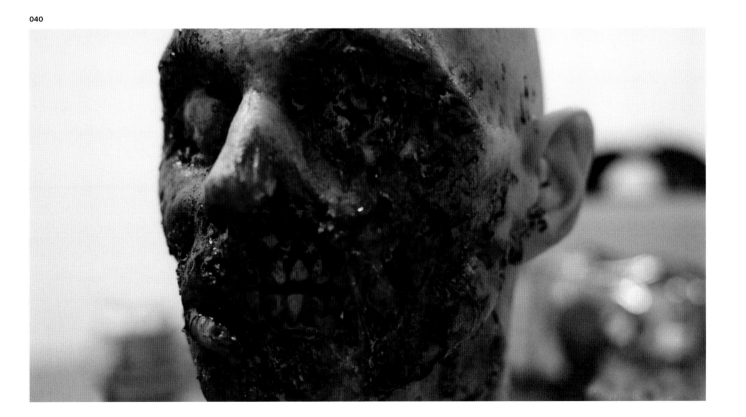

041

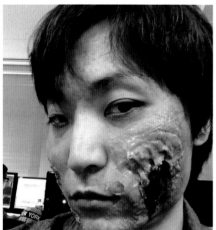

042

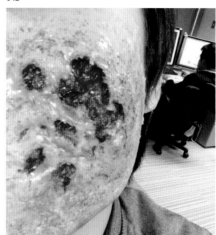

043

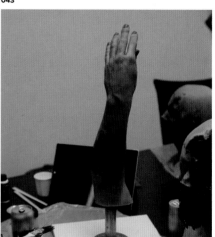

photographing and scanning could be done. This was absolutely necessary if they were going to make full use of photogrammetry. They knew asking outside studios for everything would take too much time. There were examples of similar situations in the past that taught them as much.

I'm sure many of you have heard of motion capture technology. If, for example, you want to create a humanoid 3D object and have it swing a sword in the game, you need to input each frame of that motion. This can take a massive amount of time, so a method was devised to take someone's motion in real life and capture it for use in a game. That's motion capture.

Motion capture, of course, requires a special studio with the devices necessary for capturing the motion. Back when 3D games started to become prominent, many game companies asked studios for the required motion data.

But this resulted in many problems. For example, say you want revisions for a

finished motion. Say you want to add a little something to a new motion. Then you need to go through the effort of communicating with an outside studio and explaining what you want in detail. This is highly inefficient to the point where game studios now own and share their own motion capture studios.

The design team was worried they would have those same motion capture problems with photogrammetry. All kinds of problems could occur: photography mistakes, a need to add data for revision purposes, or anything from input errors to data loss. They had any number of reasons to worry.

To avoid those risks, they needed a photo scanning studio at the company. But to build one, they of course needed Takeuchi's permission.

Setting up a studio would require a considerable budget, but based on everything Takeuchi had told them, it was clear he wanted costs kept as low as possible. On top of that, they were trying to adopt tech-

nology they had never previously used. You can see why they'd be nervous.

They calculated how much it might cost if they needed a hundred cameras. It would be fairly expensive.

"In all honesty, we had to compromise," according to Fukui.

So the design team lowered the scale, made an estimate for a modest studio that they could make up for with extra work, and submitted the idea saying, "We're going to need a 3D photo scanning studio in order to meet quality demands on *RE7*, and this is what it will cost."

Takeuchi's response to their presentation was entirely unexpected.

"Is that really all you need for a studio? No way. Tell me how much it really costs."

Shocked, the team resubmitted the idea with three times their previous budget estimate. It was easily approved. The design

team realized that by scaling back in the face of the huge cost, they had forgotten the point.

There were a few reasons for Takeuchi's response. First, he was also aware of photogrammetry. As a technology that was more efficient, produced greater quality, and could potentially be used by anyone, it fit well with Takeuchi's ideal development environment. He had even vaguely considered it might be necessary for RE7.

Regardless of the budget, adopting anything new would require additional funds to update over time, as Takeuchi knew from experience. Photogrammetry, in particular, is of lower quality the fewer cameras you have. If they'd need to get more later, it'd be better to have them set up now. He thought this would be an effective use of their money.

This brings us to the end of 2014. With the arrival of 150 single-lens reflex digital cameras, they began to set up a 3D photo scanning studio in a corner of the development floor. The development staff put it together by hand.

The biggest challenge at this time was the placement of the cameras. Accurately scanning something requires proper lighting and cameras set up 360 degrees around the subject.

Of course, if an already placed camera was even slightly shifted, they had to set it up

all over again. As a preventative measure, they put warning signs on the frames holding the cameras in place.

The paper signs said some very aggressive things that I'm hesitant to mention here, but they do express how serious the staff involved were, so I'd like to share.

Essentially, they said:

"Kick this and you die!"

(Incidentally, when the staff visited an overseas photo scanning studio to interview the staff there, they said that they put strong warnings such as "DON'T TOUCH!" on their frames.)

At last, the RE7 development team fully adopted photogrammetry. Now I'd like to write something about the results. First, all the characters, backgrounds, and other 3D objects in the game were created with

041–042
The character artist checks the quality of the special makeup on himself.

043
An elaborate replica of a left arm.

044
Zombies created with unprecedented quality thanks to photogrammetry.

044

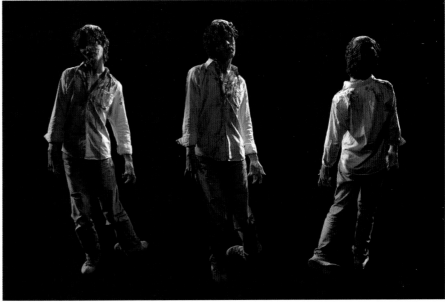

045

photogrammetry. Even the outdoor scenery was done with a simplified system that let them photograph outside. In the end, there was a noticeable jump in quality. You can see it for yourself in the demo or in the already released screenshots of *RE7*.

Also, work that would previously have taken forty days could now be done in twenty. Which is to say, two years of work was cut down to one.

Speaking on the subject, Fukui said, "Imagining the project without it gives me chills."

But it wasn't easier in every way. As previously stated, they now had to look for models and apply makeup, work they never thought they'd have to do as designers. There was no shortage of work for the design team. They also had to take completed 3D objects and touch them up so they could actually be used in the game.

046

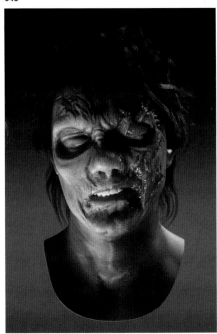

For instance, however fast you can create high-quality 3D objects, there's a limit to how many polygons game hardware can display at once, so objects have to be modified to fit. Photogrammetry also can't always recreate hair or similar things with extremely fine details, so there's often touch-up work involved. Also, as a result of having higher quality models than before, they also needed an equivalent level of motion and expression.

In general, the amount of work they could produce increased. And with the time they saved, they could improve in other areas. Nobody could doubt that photogrammetry contributed immensely to the development of *RE7*.

There's no such thing as a new technology that suddenly appears and makes game development smooth and easy. However, existing technology and ideas can be researched and adopted in a way that dramatically enhances production efficiency.

That's what photogrammetry was to the *RE7* development team. As I've said before, photogrammetry certainly isn't new technology. It's already been in use for some time in the international game industry.

However, to my knowledge, Japan has never used it on such a large Triple-A game before *RE7*.

Other game companies may have tried implementing photogrammetry before, but they likely had some doubts or concerns when they did. Would this technology really save time and increase productivity? Is it really worth the money? Most importantly, could the designers proactively adopt a technology that does away with their jobs as they know them?

045

A zombie prowling about the photo studio. So real you wouldn't think it improvised.

046–047

Modeling examples produced via photogrammetry techniques.

048

Development staff helping out for the latest scene.

047

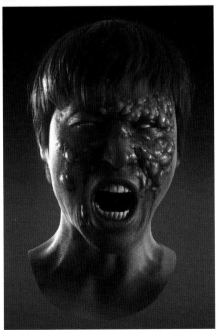

048

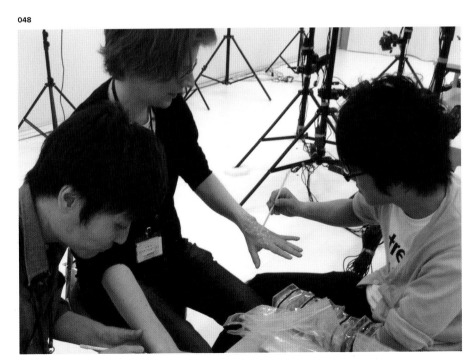

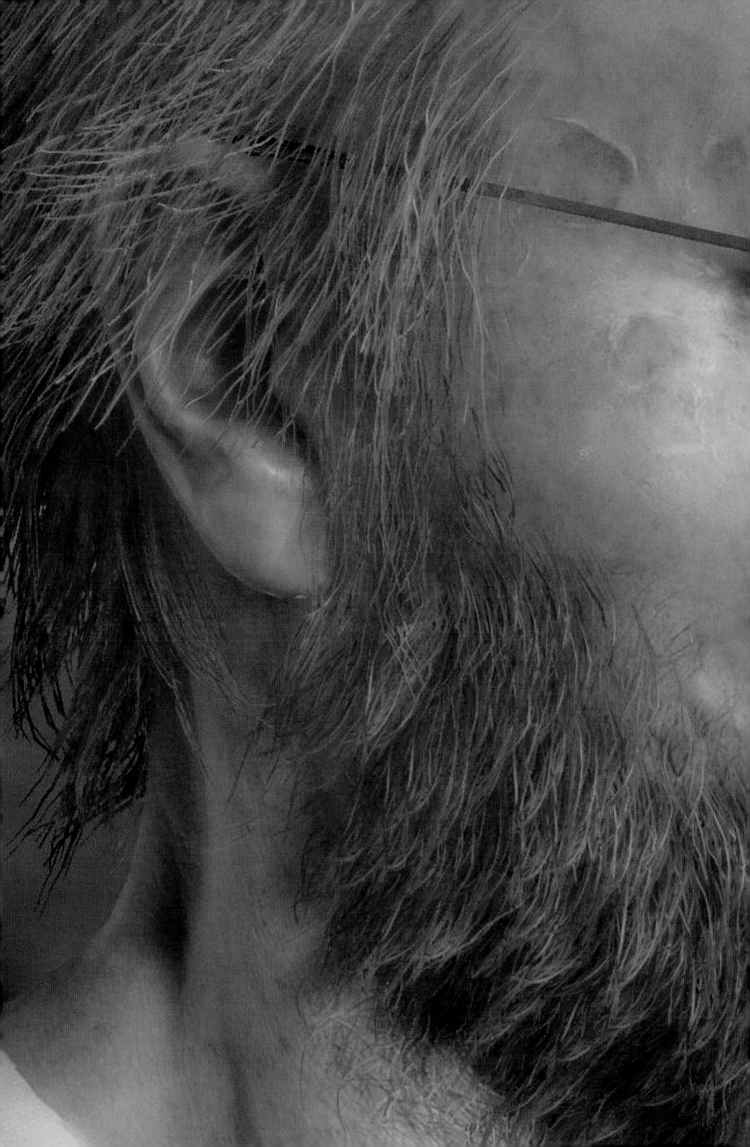

The *RE7* development team overcame those worries and fully adopted photogrammetry to stunning results. That's why their speech at CEDEC 2016 was so widely discussed. Now that *RE7* has proven the worth of photogrammetry, there's no doubt other companies will be aggressively adopting it.

"In the future, when we discuss the history of Japan's big game releases, we might need to divide it into 'Before' and 'After' *Resident Evil 7*."

Keeping an eye on the future of Japanese gaming will show us whether this turns out to be true or not.

049–050

There are a lot of items that appear in-game that were made in real life. Staff poured their hearts into their handmade props, even the eerie dolls.

051–054

The Baker family's dining table. Even the extravagant dish used in that memorable scene was created in real life. Which of these dishes do you like best?

049

051

052

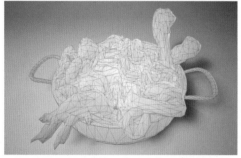

053

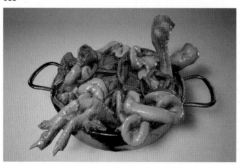

050

054

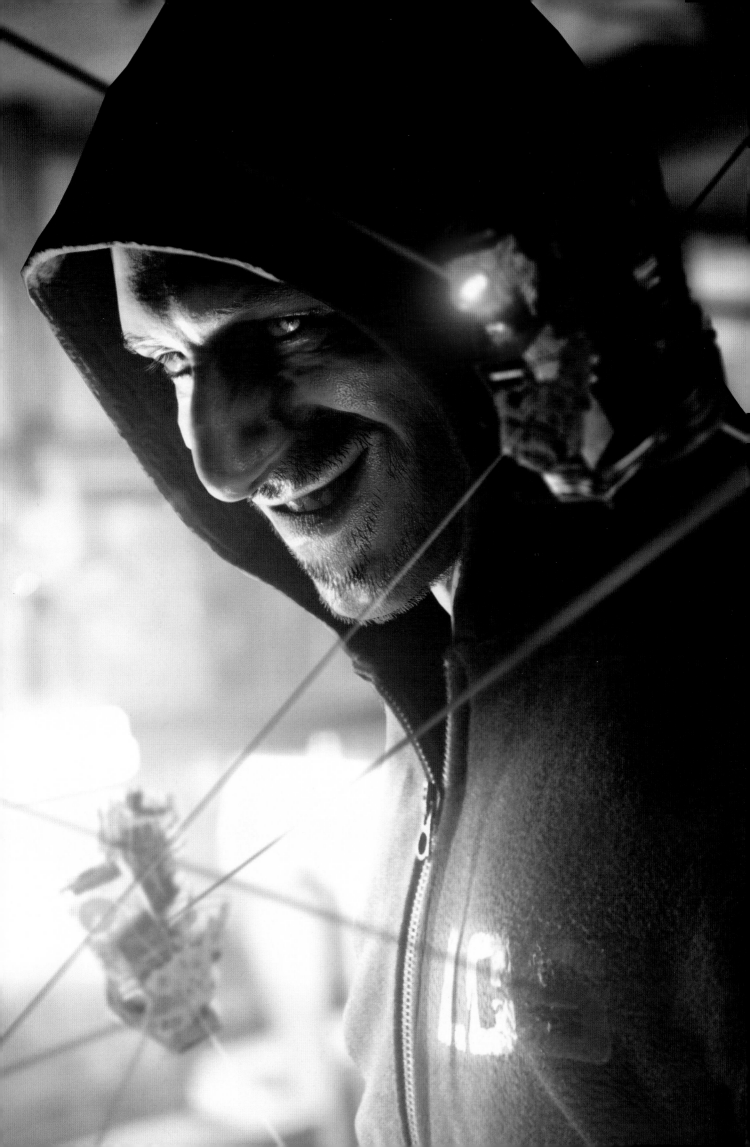

INSIDE REPORT

IX

RE ENGINE

As stated in Chapter 3, fully drawing out the power of new game hardware requires an excellent engine that optimizes the hardware, takes advantage of its full potential, and makes it easy to use.

Most game makers currently use Unreal Engine or other powerful and general-purpose engines, but some companies also develop their own engines that are better specialized for their games. Capcom is one of those companies. They have their own technology development department and a history of producing engines independently.

The prime example is the MT Framework engine. When the PS3 and Xbox 360 were released, Capcom developed it for the purpose of easily developing games for multiple platforms at once.

MT Framework saw continuous updates and remained a mainstay of Capcom's game development for over ten years. However, the engine has been around for quite a while, so barring a huge update, it can't be used on next-generation hardware. It was still possible to develop games with MT Framework, but there were various problems. Not only could it not get optimal performance out of

next-generation hardware, but its iteration speed, the rate at which it could undergo checking or changes, had also become too slow.

PS4 game production is done with development machines specifically for PS4 and PC. Code and graphic data produced on a PC is loaded into the PS4 development machine and processed until it finally displays on the screen.

When MT Framework is used in development of next-generation games, this loading and processing time is extremely drawn out. The amount of data it needs to process has increased to the point that even trying to modify a little program can take over five minutes. At the end of a production cycle, one scene needs a lot of information and processing. Even checking a minor change could take over an hour.

Something had to change, so Capcom moved ahead with development on a next-generation engine. This was before production began on the *RE* Engine. The objectives of the new engine were to have processing power that takes advantage of next-generation consoles, to create a stellar asset-based development environment, and to increase iteration speed. These

goals resemble what the *RE* Engine later accomplished.

However, the development of this engine ran into numerous big problems and ultimately had to be halted.

"1+1 didn't so much equal 2, it was actually a negative," said Satoshi Ishida, the production leader for the script module at the time. He would later become the lead programmer on *RE7*'s engine creation team.

A team was put together for each feature desired on the engine. The theory was if each team did their best on their target feature, Capcom would end up with a high-performance engine once all the features were put together. However, in reality, when the features were put together, they didn't so much add up to something great as they did devalue each other's qualities.

"Instead of trying to combine different features, we should have had one person act as the core," Ishida told me. His vision was similar to how Takeuchi felt in Chapter 3.

There was also an entirely separate issue.

"The engine creation team and the game development teams have grown distant," said Takefumi Tahara, the future manager of the *RE7* engine creation team.

It's only natural for a knowledgeable and skilled programmer to want greater functionality. However, a game engine needs more than just high functionality. Usability is directly related to efficient game development. Unfortunately, the engine they had been developing for so long was much more focused on performance than usability. Tahara, a man who worked on many games from the game developer side over sixteen years, was valued for his experience and placed in a managerial position on the project. He was to act as a coordinator between the engine development and game development sides.

At the time, Takeuchi was working in a development support position and had a clear understanding of the problems related to game engines and development. Then, in 2014, when he decided they would need a new engine for *RE7*, he called Ishida and Tahara.

With experience working on MT Framework's basic design, as well as on the halted new engine, Takeuchi could trust Ishida to be the "core" of *RE7*'s new engine. Takeuchi asked him to raise the iteration speed and told him that, other than that, he could do as he pleased. And so, Tahara, with his experience in both game engine development and game development, was made manager of the engine creation team.

The new engine needed to do two things:

1. Most importantly, it needed to be an engine for making *Resident Evil 7*. As I mentioned in Chapter 3, Takeuchi didn't need the engine to be so general purpose that other companies could use it. It simply needed to be the perfect engine for

making *RE7*. If Capcom ended up wanting to use it for other titles, they could think about how to do that later.

2. The engine also needed to have the quicker iteration speed Takeuchi asked for. Like I stated before, developing next-generation hardware with an old game engine meant excessively long loading times whenever changes were made. They needed to cut down those loading times significantly.

From April to July of 2014, Ishida and the rest of the team worked on the planning of *RE7*'s new engine. Then, at last, development on what would later be called the *RE Engine* began. Staff were called in to help, steadily increasing the number of team members.

"I paid special attention to each member's thoughts on development in order to ensure we didn't repeat the same mistakes

055

on the *RE* Engine," Tahara said, describing the situation at the time.

The *RE* Engine was meant to be an engine specialized for *RE7*. Tahara knew that when engine developers became inclined to develop an engine for the engine's sake, it ended in failure. They wouldn't be able to find success unless they changed how they did things. That's why, as a manager, he took all of his team members' thoughts into consideration.

Everyone on the *RE* Engine production team was an outstanding engineer. They had confidence and pride in their methods and felt they knew the best approach. However, that same confidence was also a disadvantage in a sense. For example, if two different members had strong opinions on the best way to do something, it caused needless clashing. That's why the team gave each necessary technology its own leader and left the authority and responsibility to them.

Also, if there was a member who went against the workflow and tried to add a function that wasn't easy to use, they were always stopped so as not to repeat the same "engine for the engine's sake" problems of the past. When a new function was added, they had to discuss it with the prototype creation teams and art creation teams.

The source code was also periodically reviewed.

This is difficult to understand, but let's say someone tried to make a program for moving a character's hand. Various programs exist inside the game, and in this case, the "hand-moving program" would require a modification to a character-related program. However, if other staff weren't aware of this hand-moving program and went into the program that manages the whole scene to control a character's hand instead of going into the "hand-moving" program, it could easily result in problems later. That's because the character side's hand-moving program and the scene side's hand-moving program could interfere with each other and potentially make the movement unstable. As such, the source code for every staff member's programs had to be checked for problems, and information had to be liberally shared in order to avoid issues.

Development went well enough that by the end of the year, the root parts of the *RE* Engine were mostly finished. In other words, it was possible to run the gray box made in Unity in the *RE* Engine.

Soon enough, work began to move everything from Unity to the *RE* Engine. However, it was when that work started that numerous problems became apparent.

As stated in Chapter 7, the prototype creation team used the general-purpose, highly flexible Unity engine's functions, making and scrapping different things as a part of a trial and error process. That method meant they didn't have much in the way of data management rules, so they weren't in a position that allowed them to easily transfer their materials over. Everything with the exception of the graphics was meant to be moved as is from Unity to the *RE* Engine. However, they were surprised to find they would have to make some unexpected changes to ensure everything ran properly. In the end, they decided that it would be faster to remake most of the data. This transfer of data from Unity to the *RE* Engine was initially anticipated to be simple, so this turned out to cause a significant delay.

Additional problems also began to pop up at this time.

This is changing topics a bit, but it is related, so I hope you don't mind.

There's a term that must come up when discussing modern game development. That would be the previously mentioned "asset-based development."

When making a game, you must have staff members that specialize in fields such as programming or graphics. And with the evolution of game hardware, the amount of required knowledge and technology is ever-growing. In the 8-bit era, one creator could take charge of jobs such as programming and graphics at the same time, but nowadays it's expected for these positions to be taken up by separate people.

As a result, game development has reached a particular stage. Let's say that the planners, in order to adjust the game's balance, want to give a character an addi-

tional attack pattern. In that situation, creating a new attack motion would require the help of designers and programmers.

It's no longer easy for the ones most involved with the full workings of the game, the planners, to make even minor changes. This situation isn't ideal. In order to address that problem, development teams created a simple programming language, a script, that gives planners more direct access to the game system.

RPG Maker probably exemplifies the concept best. While it's not simplified to that great of an extent, it's enough to make game development possible without a special skill set.

The modern game development environment is an extension of that. Sound, 3D graphics data, and general-purpose programs with functions such as asking for confirmation or opening and closing a door are called assets, and an environment where those assets are added and edited to create the game is the basis of asset-based development. Both Unity and Unreal Engines use this concept.

The RE Engine incorporates this asset-based development idea in an even more intuitive form. As a result, the amount of types of work each developer can do individually has drastically increased. Before, different tasks had to be performed in order to display a 3D character model, animate their motion, and play a footstep sound

whenever they took a step, each implemented in different ways and required the help of a programmer.

But with the easier to use asset-based development of the RE Engine, there's an asset browser registered with various types of data, from which a character model can simply be dragged and dropped in order to get it to display. Dragging the motion asset onto the character can easily make it move, and the work of timing the footstep sounds can now be done by a single planner.

The problem, however, is that we now have an environment where individuals have access to much of the development. This is fine if it's only a few people, but not even the engine creation team knew what would happen if that was expanded to a large group.

Related issues began to arise in the spring of 2015.

Let's say you put a water bottle in the game. A model designer would create the model assets for the appearance of the bottle, but someone in charge of effects would make the flowing liquid inside.

With the asset-based development-capable RE Engine, these two team members can do this work side by side. However, the problem occurs when it comes time for checking. I want you to imagine, for example, a water bottle you find inside the house. If the fluid is dirty, but the bottle

itself is strangely clean, then it comes off as unnatural. It's also true the other way around.

Another problem is that even if the effects maker finishes, they'll never have a completed asset until the model designer completes the water bottle. It's important for the entire team to share their goals, priorities, and deadlines in detail.

By the way, this problem was solved with the creation of the line structure unique to the RE7 development team. However, it would be a little longer before they put that solution in action, so I'd like to leave details on that for future chapters. What I can say is that the problems caused early on by the RE Engine were made up for with their team structure.

The engine creation team's troubles didn't stop there. Another example is the way asked the development team what they wanted in order to decide what functions would be needed. The problem is that that inevitably leads to a situation where the game's rate of completion is directly linked to the engine's development. In other words, if the engine's development didn't advance, neither would the game's. The opposite also applies. I can't discuss it in detail at the moment, but the engine development team, much like the game development team, would go through many twists and turns.

At this point, I'd like to focus on what the RE Engine has accomplished.

First, it's enabled photorealism, which allows for graphics so lifelike that they're hard to distinguish from reality and ready to be played at a high frame rate.

Also, it allowed each individual member of the development team to make a wide variety of different changes. There is one scene that best illustrates this accomplishment. I can't offer too many details, but there is a boss battle in the game that we'll call the "Garage Battle." From what I saw, this is likely the battle sequence that underwent the most changes of any in the game. What lies behind that is the uncompromising trial and error of everyone involved trying to make it as good as possible, and that was made possible by the easy to use, asset-based development environment provided by the *RE* Engine.

The boss has a complicated movement pattern, the stage goes through various changes, and it ends with a shocking conclusion. The final version of the garage battle will no doubt leave you stunned. Even I wondered how complex the programming had to be, but it was all put together with functions built into the *RE* Engine. I hope you remember this when you play the garage battle for yourself.

Essentially, the *RE* Engine drastically increased both the ease of use for staff other than programmers and the graphical performance. These two points don't normally mix, so the fact that it didn't sacrifice either is particularly remarkable.

Also, the *RE* Engine would later have macro functions implemented. On previous Capcom games, when someone on the game development side wanted a function added to the engine, they first had to submit a written request to an engineer and wait for it to pass examination, then wait some more until it'd finally appear in the engine. But with *RE* Engine, there are functions for developers of any individual game to freely customize it to some extent. The time spent waiting for the engine side to make adjustments has been considerably reduced.

One of the initial goals, raising the iteration speed, has also proven to be outstandingly effective. When *RE7* development was at its peak, the iteration speed had reduced the loading time to practically zero. This even had a positive effect on *RE7* itself. The radical decrease in work time meant there was more time for brushing up, raising the quality of the game.

"*RE7* may be finished, but the *RE* Engine isn't. There'll be more updates yet to come," Takeuchi said.

The *RE* in *RE* Engine is actually not "*Resident Evil*," but "Reach for the Moon." Meaning, it's intended to reach places not previously thought possible by man and make the impossible a reality.

The *RE* Engine was born as an engine specialized for the development of *RE7*. That doesn't just mean it can more quickly carry out high-level processing. The *RE7* team learned about what type of environment would provide the most game development efficiency and accessibility, then built that into *RE* Engine. Now that the *RE* Engine has that experience, it's no longer just a "specialized" engine.

Nobody knows how far this engine will go in the end, but it will unquestionably be used in many future Capcom titles. How will the *RE* Engine change Capcom in the future? It'll be interesting to watch and see what happens.

055
Grenade launcher. You can see that the ammo was made by modifying a container like canned food.

INSIDE REPORT

X

THE FIRST CONVERGENCE

Being the latest installment of a large series meant that *RE7* was expected to run into developmental difficulties—Kawata repeatedly told me that everything was going smoothly.

It's true that development went as planned from the midpoint until the end, but it's also true that, behind that, the developers faced a plethora of challenges. For example, I'm sure you've already seen plenty of screenshots of *RE7*, and maybe you've played the demo and actually explored the house yourself too. I think most can agree that as far as graphics go, *RE7* is of quality truly worthy of a next-generation installment of a major series. But reaching that point took considerable work from the creators.

As I mentioned in Chapter 7, the *RE7* development team really got down to work in April 2014 with the goal of completing the vertical slice within one year's time. On the way to the vertical slice's completion, a gray box (a prototype intended to give an idea of all the game's concepts and the basic flow) was created.

During this period, the development team had a massive number of ideas, and the gray box changed and evolved daily.

Then, at the end of 2014, the prototype creation team was split into two. One team continued to work on the gray box while the other took what was already completed and worked on porting it into the *RE* Engine. Basically, real work on the vertical slice had begun.

2014 could be called a trial and error period, a time to think big and try out ideas. But this all changed in 2015. Let's focus on the vertical slice creation team first. The flow of their development shifted gears toward convergence.

A vertical slice allows you to play only a limited part of the game, but that part needs to include everything one would find in the final product. That is to say, a team cannot make a vertical slice if they don't know when to call it complete. When the time came to try and form everything into a game, the project ran into a problem.

The gray box was a bountiful farm, but it also needed to be tended to. It grew plenty of useful crops, but there was no shortage of weeds.

Truthfully, the *RE7* development team saw this coming. That's because they had

assumed ahead of time that they would need to make changes in the future and set up their development schedule around repeated trial and error. However, in the midst of development, *RE7*'s problems turned out to be bigger than had been expected. As I've previously mentioned, even the act of transferring everything from Unity to the *RE* Engine had major issues.

And while the schedule allowed time for these kinds of issues to be addressed, the convergence process still wasn't easy. It would require cutting off the constant flow of ideas and deleting the work of some, or possibly ordering them to go in a whole new direction.

Completely cutting something that a staff member worked hard on can potentially lead to a drop in motivation. Even so, if something was deemed unnecessary, they couldn't hesitate to remove it. Takeuchi, with all of his development experience, knew this well. That's why he was merciless.

I have one example to relay.

Toshihiko Tsuda, a designer with Capcom for thirteen years, was one of the core members who were around at the very beginning to make *RE7*'s concept movie.

As an art director, he was responsible for producing background graphics as well as performing quality checks on the house's walls, floor, and an assortment of small objects. The art team was also one of the larger teams and needed considerable skill to handle, which Tsuda had a knack for, so Kawata valued him for his management talent.

Tsuda was excited. The reason Takeuchi's idea to create an all-new *Resident Evil* resonated so deeply with Tsuda was, of course, the fact that it was being developed for next-generation consoles where near-photorealistic graphics were possible. Tsuda himself felt that if they were developing for a next-generation console, it had to reach a certain level of quality. They also had new technology at their disposal, photogrammetry. Any object they might want to place in the game could be added in greater detail than ever. Tsuda tried to put all kinds of extremely high-quality

objects in the game in order to make it more frightening.

However, there was a big problem: the quality of the individual objects was too high.

For example, Tsuda spent two weeks creating a deck of cards as a test. It was created, of course, with photogrammetry, which is by no means a perfect technology. The 3D object still had to be touched up by a designer before it could be placed into the game. The touch-up process consumed two weeks.

Still, Tsuda believed this is what the next generation of game making would be like. There was no doubt that the process resulted in a high-quality final product, and that was enough to satisfy him.

But maybe the choice of putting a lot of objects in a horror game wasn't the right

one. The decrepit house would become so full of garbage that there'd be no place to stand, and the player wouldn't even be able to tell which items were the ones they needed to pick up.

Also, as the game became more defined, another problem arose. If they kept making objects at this quality, the specs of next-generation consoles wouldn't be powerful enough to run the vertical slice. Besides this, the amount of work was massive. They couldn't even finish a single part of a stage this way. Making the entire game at this quality would take far more time and manpower than they had.

But could they do nothing to avoid reducing the quality? Tsuda's testing continued. He retained his "place lots of objects" idea and used lighting to make objects distinguishable from the background, creating a creepy mood. However, the sheer volume of high polygon count 3D items, combined

056

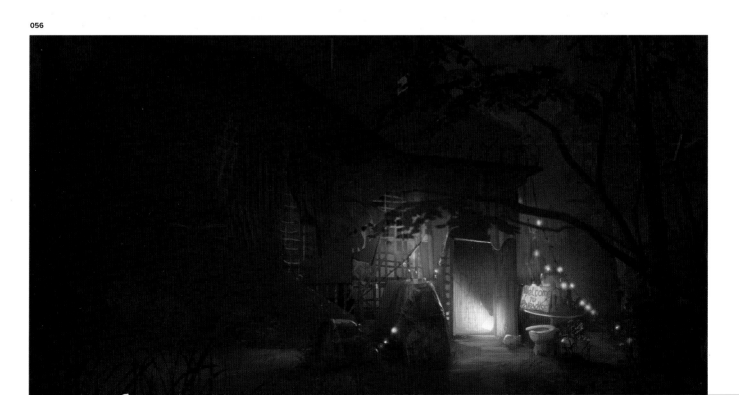

057

with the special lighting, still rendered the game unplayable on next-generation consoles. He considered giving the player a flashlight that gave them limited sight of the screen, but nothing worked out. He knew it was bad, but he had no replacement ideas. According to him, the idea had "gone bad."

At the start of the spring of 2015, when the vertical slice was due to be finished, Takeuchi spoke to Tsuda.

"If you still can't do it at this point, I don't know if it's working."

So, the method they had used up until that point was completely abandoned.

Takeuchi had previously said the following about how a head of development should pass judgment.

"The first thing you need to ask is whether something's superb or not. If it's good work, compliment them, that's all there is to it. If it's bad, make them do it over again, no matter how many times it takes."

Of course, from the perspective of the one being forced to repeatedly redo things, this may be overly harsh. But from the head of development's perspective, it's only natural to order bad work to be redone. Another staff member told me the following in regards to Takeuchi's criticism.

"Takeuchi's criticism is extremely brutal, but it's always on the mark. We aren't positive every part of our work is good either. That's why it hurts so much when it's pointed out."

Considering his position, Takeuchi may have been right to ask for do-overs, but for someone like Tsuda, who was organizing

the artists and taking responsibility for the graphic quality, it had an extremely damaging impact. He was so depressed that his family was even concerned.

After much consideration, Tsuda decided that, as the man in charge, he couldn't put this burden on his team any longer and talked to Takeuchi.

"Can you take me off the team?"

But Takeuchi's responded with neither a yes nor a no.

"You don't really want that, do you?"

He questioned Tsuda's true feelings.

Tsuda's chosen method for making *RE7*'s backgrounds may not have been the best, but he was a creator, a core member, and

058

one of the people they needed for the game's development. Takeuchi was confident Tsuda would be able to pull it off in the end. In particular, Takeuchi saw that Tsuda's creative ideas for *RE7* were extremely strong. Takeuchi wanted Tsuda to make a decision after looking at the big picture.

After hearing that from Takeuchi, Tsuda came to the conclusion that he wasn't done with *RE7* yet. Excited to take on the next generation of hardware, he may have gotten his hopes up too high. After taking a step back and looking at the background graphics, he was able to see what he should prioritize. The process of doing things over also allowed him to get a feel for the capacity of next-generation hardware.

Tsuda worked within the capabilities of the hardware and prioritized what work *RE7* really needed, going back and reviewing

one element at a time. That was the simplest solution.

When I asked Takeuchi about how he came to the decision I just mentioned, he said the following.

"Ultimately, this approach proved most effective with the backgrounds. Tsuda, as a leader, was unsure what to do at times, but he came through for us."

I didn't know much about Tsuda yet when I heard this from Takeuchi. Tsuda struggled within this new field, and things sometimes went poorly, but in the end, he did a splendid job and met Takeuchi's expectations. He also successfully created outstanding, atmospheric graphics.

This anecdote, of course, only describes one of the many things that happened in

the development of *RE7*. In April 2015, after more twists and turns than can be properly described, the vertical slice was finished. As I mentioned in "Inside Report IV," the vertical slice was unveiled to all of Capcom's staff and blew them away.

Then, the development of *RE7* proceeded to the next stage.

056
A lab on the grounds. This area is controlled by Lucas.

057–058
The entrance besmeared with white. What is the cord leading into the back connected to?

INSIDE REPORT

XI

A CHANGE IN DEVELOPMENT STRUCTURE

It was April of 2015. After the goal of creating a vertical slice was met, the *RE7* development team was about to enter a new stage of development.

This had been the plan from the beginning.

After the past year of experiences, trial and error, various accomplishments and accidents along the way, the completion of the vertical slice, and the progress made on the gray box, the development team knew what they needed to do to complete *RE7*.

Armed with that knowledge, they switched to a more efficient system of development. One could say this flexible team-based operating method of assuming in advance that alterations will be made and having periodic reviews was a unique feature of the *RE7* development team. Having worked on many games, Takeuchi, Kadono, Nakanishi, and others were well aware of what kind of development structure and course of action would be needed.

As I touched on in a previous chapter, the *RE7* development team would have meetings each Friday afternoon to report progress and discuss what to do next as a group. In late April, during one of these meetings, Kadono suggested a fresh idea for team structure and brought up the following points:

• Thinking in a new way.

• Setting up the P.M.O (Project Management Office)

• Transitioning to line structure.

What they first had each member do was change their thinking. Now that the trial and error period was over, it was time to move onto the next step, taking ideas and findings and building on them to produce a completed product. Doing so would, of course, require switching to a different approach.

For example, at this time, Takeuchi and the other members of the team were fairly satisfied with the vertical slice. They had, at the very least, succeeded in building *RE7*'s representative element—namely, horror.

But on the other hand, the game still hadn't become "*Resident Evil*." In other words, it was still lacking when it came to the elements that make *Resident Evil* what it is, elements like the use of limited ammo and the process of taking on terrifying creatures while progressing through dangerous areas.

The team needed to start working on those aspects of the gameplay in order to create a complete *Resident Evil* package.

Additionally, while much of what they had done so far had been developed strictly within the company, what came next would require outsourcing to companies worldwide. For example, the photogrammetry studio was already complete, but touch up work would be needed if the 3D objects made with the studio were to be used in the game. The work involved was so massive that they asked a specialized company overseas to help. That required setting the details of how the work would be done and submitted.

There were also some motions, voices, and other elements that they had to record overseas. At this point in time, they had the general story set up. But for the sake of better presentation, they needed a more detailed plot that would explain specific situations.

While necessary for the completion of *RE7*, the transition from trial and error to convergence that was occurring at this time could possibly also be called a switch from freedom to restriction.

Next came the establishment of the P.M.O. As I mentioned in "Inside Report V," Kadono

059

060

had been the only project manager up until this point, but after looking back on the experiences of the last year and considering what would likely happen in the future, it became clear that one person wouldn't be able to manage everything.

That's why the P.M.O, also mentioned in "Inside Report V," was set up. The P.M.O was made up of three project managers including Kadono, plus two assistants, making a total of five members.

The new project managers were Yoshizumi Hori and Hiroyuki Chi. As a side note, they were already in a managerial position prior to becoming members of the P.M.O and often discussed the schedule with Kadono.

Hori had started off in business but later became a designer. His charge is the choice of the outside order, a contract, management. But this was no easy job.

I want you to imagine an event scene. Each event needs a script, characters, a stage, multiple objects and 3D assets, and character voices and motions.

On *RE7*, 3D asset production and editing were outsourced everywhere from China and Taiwan to Britain and Canada—truly all over the world. Assistance with the story came from a writer in Texas, while character motions in event scenes were put together by setting up something of a movie set and doing motion capture. That was done in Los Angeles. However, the motion data obtained through motion capture can't just be used as is. To put it in the game, some "cleaning" work is necessary. That work was outsourced to China and India.

In the end, at least three hundred people did outsourced work on *RE7*, and Hori was responsible for organizing it all. I think that should give you a good idea of how demanding his role was.

Organization wasn't all he did. Project managers also act in a supervising capacity. Hori sifted through ideas that had been presented to him, also adding some of his own, contributing greatly to *RE7*. Tsuda, the art director I discussed last chapter, had this to say:

"He's quick to make judgments. It might look like his decisions are based on instinct, but they're certainly coming from experience. We only see the individual components, but Hori looks at the big picture for us, so he's a lot of help."

His praise for Hori was glowing.

Chi, the third project manager, was always smiling and telling jokes. Of course, that's not all he did. His experience working at what might be the biggest game maker outside Japan led to him being made an art director on *RE7* in the spring of 2014.

Some may have noticed already, but this report lists Chi as a third art director, after Takano and Tsuda.

Nakanishi described the differences between the three of them in the following way.

"Chi proposes the approach. Takano thinks of the ideas. Tsuda figures out how to implement them."

061

With his experience on big, international titles, Chi's proposals on new methods contributed a lot to the development of *RE7*.

One example was the creation of the "Mood Board."

This was used to take Takeuchi's vision and insert it into the art and implementation to make the game a singular whole.

RE7 came to require a massive number of background objects. It was impossible for one person to take care of everything, but if many people were going to get involved, they all had to share the same vision. So, the team collected already existing photos

and videos that resembled their intended concept, creating a process where they used those photos and videos to decide what items should and shouldn't be in certain areas.

They wanted horror, but not necessarily an occult atmosphere. Ideas submitted without a complete understanding of the game concept would be pointless. Chi used images to clearly communicate the mood and feeling he was aiming for in *RE7*.

Chi also tried his best to approach *RE7* as a game that would release in two years' time. For example, in 2014, new *Uncharted* and *Battlefield* games were announced.

RE7 would be compared to other similar Triple-A games. As such, Chi had to ensure then that *RE7* would be of comparable quality to other Triple-A games to be released in two years.

The already revealed *RE7* graphics do, indeed, compete with any other Triple-A title. The team's ability to look ahead to the future in terms of art direction was thanks in no small part to Chi's experience.

The next thing announced by the P.M.O was a new development structure. Up until this point, the *RE7* development team had emphasized quick production and revision iterations by using the Scrum model.

062

But, from this point onwards, they would need something more structured. As such, they switched from the Scrum model to the Waterfall model.

However, as I explained in "Inside Report VI," they used a new form of the Waterfall model which they called line structure. Of course, this was a development structure unique to the *RE7* development team. Now that we've touched on details of the *RE* Engine and *RE7*'s development, I'd like to focus on this line structure.

Kadono conceived of the line structure around the end of 2014.

Let's say you make one character that appears in the game. In traditional game development, a designer would design that character's appearance based on provided specifications, a modeler would make the 3D object, an animator would create the motions, and ultimately, a programmer would get it all working together.

But everyone involved prioritizes work differently. And different staff members

may disagree on which characters should be made as presented or which need alterations, meaning the time needed to finish a character could vary wildly. As such, it's impossible to perform a check before the work is done, and it's possible that problems will arise at the end when everything's being put together.

And if, say, there are staff members working on a battle, some may be unable to do their job without a particular character available.

Until that character has reached a certain degree of completion, their work grinds to a halt.

Such an issue occurred early in 2015 when the vertical slice was being assembled on the *RE* Engine. I'd like you to think back to the water bottle example I presented in "Insider Report IX." When the bottle and the fluid's two different staffs were working independently, they each progressed at different rates and finished at different times meaning an incomplete asset was used in the game during development,

which caused a variety of delays and problems.

There was another problem as well. In 2015, the vertical slice team entered the convergence period before the other teams. That made the transition into convergence a difficult one.

Staff members were given free rein to try whatever they wanted during the trial and error phase. Nobody had to think about anyone else's work, they just focused on their own goals.

However, when they attempted to put all that work together, it became a situation where one component would break another. In order to avoid wasting work, ideas and functions that the hardware's processing likely couldn't handle were tested anyway. But this started to increase the processing time even further.

The team wouldn't be able to make *RE7* into the kind of game they were aiming for without making use of everyone's area of expertise. But completing the vertical slice taught the team a lesson: if each team member only considered their own role, they'd never be able to unite everyone's work into a cohesive whole.

Kadono was worried. The impending convergence would involve not only the vertical slice creation team, but also the entirety of *RE7* development. It was easy to see that things would only grow more strained if something didn't change.

Kadono asked himself what they could do to avoid problems in the future.

It was then that he suddenly thought of a factory's production line.

In a production line, the staff members needed to create a single product is brought together, and then each staff member finishes their part of the job before handing it off to the next person, pushing it toward completion. And when it reaches the end of the production line, you have a finished product.

If the issue was that differing priorities were causing assets to be used in an incomplete state and bringing about problems, all the team had to do was make sure everyone could always finish their work properly before handing it off to the next staff member. If the creation of one asset required people from multiple fields to be involved, they just had to have all those people work together.

Kadono put his line structure plan into action by assembling designers, planners, programmers, and other staff into "lines," and having them complete assets to the point where they could easily be handled by other members. Returning to the water bottle example, the act of placing the creators of both the bottle and the water in the same line meant they could work together and share progress and priorities. That allowed the team to get around the check function that had been an issue with the *RE* Engine at the time, and if they were to share a complete or near-complete water bottle, other lines could easily pull it out of the asset browser if necessary.

Once the assets, backgrounds, and every other necessary part of the game were finished, the parts could simply be put together and the game would function. However, with that system in place, some-one had to be the one to assemble the parts. For that, a line focused on level design was set up.

Thus, the *RE7* development team went from the Scrum model to the line structure, which was effectively a version of the waterfall model adapted to the *RE* Engine and *RE7*. The game would from then on be developed by the level design, background asset, and character production lines I mentioned in "Insider Report VII." (By the

063

way, the change from "trial and error" to "convergence" was not welcomed by all of the dev team.)

And so, it was at this time that the *RE7* development team began to head into convergence. However, as I mentioned before, it was also at this time that the team's mood dampened. The development environment had been full of ideas and incredibly lively up until this point. An intentional shift was made to transition to something more orderly. Of course, some ideas were scrapped as well.

Such changes can be hard for creatives to accept, putting them in a bad mood. Project head Takeuchi said the following regarding all of this:

"The time period we were to converge all development was already set. I knew that the atmosphere around the workplace would get bad around that time. But at times like that, we prune too much and the game loses its fun factor. So there will be a time (after pruning) when we actively throw out ideas. I knew that everyone would regain their motivation there."

As a side note, this is heavily based on Takeuchi's experience with the development of past games. On a particular project where Takeuchi was the producer, convergence was planned to take place near the end of development rather than at the midpoint.

He also figured that the starting line for when they entered the convergence

period should be set high. If the starting point was high, he thought the endpoint would naturally be high as well.

But while the game ultimately turned out well, development itself didn't go smoothly.

Setting a high standard for when they would start convergence meant that the team didn't have sufficient time towards the end of convergence, and most of the last stage of development was spent on work like fixing bugs, significantly diminishing the team's feelings of accomplishment. It wasn't a workplace worthy of creating games, something that should be a form of entertainment.

He wanted to fix this on *RE7*. To do so, he moved the convergence period from the end of the project to the middle. Of course, the midpoint was too early for convergence. But in exchange, it left room for new ideas to be tested in the future. He believed that would allow the team to reach the end of development without losing their creative spirit.

Ultimately, it was during this convergence period that *RE7* began to take shape, speeding up development. In fact, the game's stages were largely finished by the fall of that year. However, *Resident Evil 7* was still far from complete, and the team was about to enter another period of trial and error. It was only possible for the team to go through his new stage of development because they had already experienced it.

059
Louisiana College of the South. Could this be Lucas's alma mater?

060
Mr. Everywhere statuettes placed throughout the Baker residence.

061
Image of a wonderful birthday party.

062
Designs for the hanging, tombstone, and fetus that appear in the birthday found footage.

063
Lucas's party room full of traps.

INSIDE REPORT

XII

CHALLENGES—FULLY COMPATIBLE WITH VR

The term VR (Virtual Reality) has existed for twenty years, but it only began to garner worldwide attention around 2012.

That was the year the VR system known as the Oculus Rift appeared on Kickstarter, a crowdfunding site. It accrued so much money through the site that it became widely discussed.

In 2013, when Oculus Rift development kits began to be sent to backers, innovation-loving engineers around the world, among others, started to take an interest. Many contents were developed or announced that, while unrefined, showed the potential of VR and brought the rise of a big movement.

This was as true at Capcom as it was anywhere else. In 2013, a number of creatives with interest in VR naturally came together and started to do research. Acting entirely out of personal interest, the creators worked independently without any orders from the company.

Many of you may be reminded of something. Yes, it resembles when the company began with photogrammetry. A group that would be called the "VR Fan Club" even came together for research purposes.

For E3, RE7 announced to be fully playable with PS VR, Capcom was most certainly not working actively in VR when development began at the start of 2014.

"Somewhere in the plans was scribbled 'To be compatible with VR,' but that was about it. Even that was only written because working with new things improves motivation," Nakanishi said.

Nakanishi was one of the people interested in VR. His thought was that, as a horror game with a first-person perspective, RE7 had the potential to work well with VR.

But, although Takeuchi was usually enthusiastic about taking on new challenges, he wasn't entirely on board the idea of VR.

However, while making the game VR compatible was a goal for the future, they prioritized developing RE7 itself. As a result, there was no major progress in regards to VR for a while after production fully started in April 2014. There was the prototype, art, and RE Engine teams, but no VR team.

However, one of the new members who joined the RE7 development team that April

was Kazuhiro Takahara. After joining Capcom in 2007, he worked as a programmer on Lost Planet 2, going on to work on engine development and other technologies that made up the basis of game creation.

Takahara—a member of the VR Fan Club— was one of those who saw the potential of VR. He bought an Oculus Rift development kit on his own and used it for research. "Research" sounds formal, but Takahara described it as "a new toy I couldn't keep my hands off of."

As a part of the RE7 development team, Takahara led the push to make RE7 virtual reality compatible while simultaneously working on the creation of both the RE Engine and its prototype.

However, at this stage, before the vertical slice was even finished and a lack of VR development resources were available, he had no means of taking action for VR. This changed in 2015. It was around this time that the RE7 development team received some new development materials. It was what would later become officially known as the PlayStation VR, "Project Morpheus."

This is when RE7 finally began looking into making the game compatible with PS VR.

At this point, the plans were still limited to partial compatibility, only some select event scenes.

The work to make *RE7* virtual reality compatible had begun. Takahara and the VR Fan Club were, of course, at the center of this effort. They were far more interested than most in PS VR, and they were also extremely passionate about development.

Takahara, "When I wasn't used to it at first, I got so sick testing VR for hours on end I thought it was a form of torture."

In fact, when I came to the development room to interview for *7*, I saw him wearing the Morpheus (PS VR) with a pale face.

"I would spend all day wearing and taking off the PS VR over and over. The blue LED floating around the development floor made it feel like some futuristic workplace. At first, I was hit with that VR sickness, but strangely enough I got used to wearing the PS VR all day."

Takahara also said the following:

"Tinkering with the PS VR was a lot of fun. It was exhausting at times, of course, but it was brand new technology, and figuring out how to make a horror game on it that didn't make people sick required thinking up and testing new ideas. That was very enjoyable."

Thanks in part to the VR Fan Club's passionate research, the team was able to gather a lot of information about PS VR technology, some of which was used in the *RE* Engine's development. It was also at this time that the *RE7* development team first decided they wanted to create some sort of VR demo. The plan was to present it at the world's biggest video game industry convention, E3 2015 (Electronic Entertainment Expo).

At E3, the guests wouldn't have that much time to test the demo, they'd be playing it for the first time so using something as unfamiliar as the PS VR meant the team couldn't make anything too complex. Numerous ideas were considered.

Because *Resident Evil VII* on PS VR is in first-person perspective, it gave objects flying at the player much more impact. The team considered creating a game where the player had to dodge such objects. *Resident Evil VII* on PS VR also induced a strange, floating sensation when the player jumped or fell.

The team also considered creating a poltergeist-like flying chair phenomenon.

However, despite many strange ideas centering on "the affinity with VR," Takeuchi rejected those ideas.

"This is no good for *RE7*."

In the end, they settled on a simpler idea that simulated the fear of being stabbed. They ended up creating a demo called *Kitchen* that's now available on PS VR. Basically, in the demo, the protagonist is bound to a chair while various horrifying things happen around them, ending with something to shock the player.

At first, the team was unsure about presenting something so plain. "The team had spent a long time creating horror, so they were numb to it," Takeuchi said.

"But I was confident that they'd be surprised if I actually had them experience it."

At E3 2015 June, Takeuchi's confidence and vision became the reality.

Everyone who played *Kitchen* quivered with terror. Endless screams filled the convention floor and countless articles were written about how it was "truly frightening."

Reaction videos of people playing *Kitchen* were also recorded and released, sparking widespread discussion and garnering an ever-rising number of views.

I played the demo myself at Tokyo Game Show 2015, and I'll never forget the impact it had on me. I can't even tell you how many times I thought about taking off the PS VR and running away. It was so terrifying that I actually resented the developers for making me experience it. One scene in particular got to me, the one where the main character is stabbed in the thigh.

The moment the player was stabbed, I felt a strange sensation like I really was being stabbed myself.

I think a lot of people know that since this E3, expectations of the PS VR have risen greatly. A lot of people must have felt the great potential of the all-new VR and horror experience that *Kitchen* presented.

And it heavily influenced *RE7*'s development team as well. They were able to reconfirm that the horror tone they were after was not mistaken. The success of *Kitchen* proved that the PS VR was even more compatible with horror than they imagined; fear and pain have no borders between countries.

The reaction to the demo would make them take on an incredible challenge: to make all of *RE7* playable on the PS VR with full compatibility.

The following story is a bit of a tangent, but it was at this time that Kawata was revealed to be the producer of *Kitchen*. This announcement, coupled with the fact that *Kitchen* is a horror game, piqued the interest of a small segment of fans. They began to suspect that *Kitchen* might be a part of the new *Resident Evil* game.

However, it would be some time before the truth was revealed.

During E3 of the following year, the development team did not show a game image of *Kitchen* at all and kept detailed information surrounding the demo hidden.

Returning to the story, the problem with *RE7* becoming fully compatible with PS VR was a large workload; *RE7* itself wasn't even finished at this point. Would adding more work to make the game fully compatible with PS VR be a good move? Would it alter the schedule?

Not only that, but *RE7* was being made with the still incomplete *RE* Engine. To make the full game PS VR compatible, they would have to make the *RE* Engine compatible with VR as well. Just how much work and technique would have to be invested in that?

This was no easy task.

And there was still the motion VR sickness issue. In *Kitchen*, the player remains stationary while moving their upper body—the movement of the character in the game and the movement of the player are hardly different, so it was difficult to get motion sickness.

However, were they to make all of *RE7* playable on PS VR, would the VR motion sickness issue inevitably resurface? Was a technological solution to this problem possible?

At this point, the team was lacking in system structure and experience with VR technology. Many of the developers voiced their concerns. One problem was that the graphics and perspective control weren't made with PS VR in mind. What if using PS VR allowed the player to see an area they couldn't before? Or what if controlling the perspective with PS VR changed the difficulty of battles? It was the same with sound. The sound effects were created with the idea that players would be playing on a monitor speaker or headphones. The team would now have to check and see how the game's sound design worked on PS VR.

Many debates were had within the team and much testing was done.

There was another game show that could help them decide. It was September's Tokyo Game Show 2015. *Kitchen* was originally created for E3 2015, so it needed some tweaks to be exhibited in Japan.

In addition to those tweaks, energy and time were also spent on new assets and various other improvements. It was probably thanks to those adjustments that the response at the Tokyo Game Show was even greater than at E3, convincing attendees a second time.

The entire *RE7* development team got together for a meeting each Friday. Each individual team would share their progress and discuss what they intended to do next. In October 2015, Takeuchi declared the following at one of these meetings:

"Thanks to the hard work of the VR team, the reaction to *Kitchen* has been extremely positive. As such, after much discussion, we have decided to make the game fully compatible with PS VR."

Though everyone knew it would be a massive amount of additional work, they took on the challenge.

With the *RE7* development team working at the forefront, the earnest efforts continued. Even the biggest issue, VR-induced motion sickness, had many countermeasures tested and taken in less than a year.

The cause of VR sickness was already well-known. Putting it in simple terms, it's the "discrepancy between the expected and the perceived."

For example, say you turned your field of vision thirty degrees to the right in a virtual space. The scenery you see also has to turn thirty degrees to the right at that same speed—but, for various reasons, you end up seeing things differently from reality. When that discrepancy occurs, the information from the sense that processes sight (vision) and the sense that processes movement (the semicircular canals) differ. The result is a feeling of sickness.

3D game-induced motion sickness is effectively the same as any other kind of motion sickness. After constant research, the specifics of this phenomenon as it occurs with VR were discovered.

"If you constantly move forward in a narrow passageway, it can look as though the walls are moving faster than bodily sensation. As a result, it creates the illusion that you, yourself, are moving faster, making it easier to experience VR fatigue," Takahara said.

To handle such problems, they had the protagonist walk at 6.1km/h when playing the game normally, but 4.2km/h when playing with VR.

But the change in speed significantly affected the gameplay. Creatures that had previously been difficult to outrun were now inescapable, and I'm sure you can imagine that combat was also made more difficult.

Then, they set up the PS VR version so that the player's movement speed would vary depending on the scene. For example, gameplay became significantly more

comfortable if the player moved at 4.2km/h while exploring, but 6.1km/h just while in battle.

It changed depending on a sequence and the obstacles of VR gameplay were greatly reduced.

There were also measures taken for collision detection problems. For example, when a player walks, the height of the protagonist's collision detection with the floor was adjusted. Flat surfaces such as hallways caused relatively few problems, but hilly outdoor areas would naturally force the player to visually experience a lot of vertical movement. Just like carsickness, movements of the field of vision like this are not very compatible with VR. So, they had the PS VR mode differ from the normal gameplay, placing hit detection spots so that one's movements would be smooth arcs, even outside, limiting the amount of shaking in vision, therefore preventing motion sickness.

They tackled each problem one by one like this, finally completing the feat of making *RE7* completely PS VR compatible. This result is definitely thanks to the passion and efforts of the engineers. I also would like to give high praise to the management for foreseeing the mass amount of extra work that was bound to occur during development and making things fall in place without having to extend the schedule.

I'll add that *RE7* is probably the world's first big Triple-A game that's fully compatible

with VR. Like the presentation at CEDEC 2016, the team's experiences and accomplishments made waves not only within Capcom but also around the world.

I'd like to end with Takahara's three "VR Game Development Fundamentals" from his CEDEC 2016 presentation:

1. Don't think, test.

2. Don't be limited by old methods.

3. There's still more to learn.

064
Rough design. Jack Baker's completed transformation. He still maintains a human form in the design, but in the game, he has a grotesque, giant, Molded-like transformation (the picture at the top of the page).

064

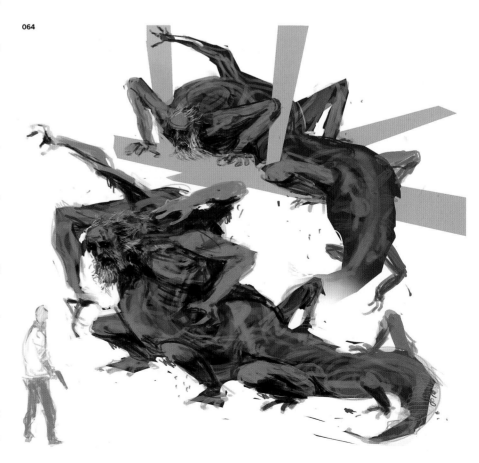

INSIDE REPORT

XIII
THE FINAL STAGE

Various versions of a completed game are created over the course of development. Most people probably hadn't heard of the vertical slice I discussed, but I'm sure many of you know about alpha, beta, and gold master versions.

To simply describe each:

• An alpha contains most of a game's components and allows for all the game's functions and capabilities to be evaluated.

• A beta, much like the alpha, is for evaluation purposes, but it's closer to the final product. Betas generally contain every function the game needs and have had game-breaking defects removed.

• A gold master is the finished product.

However, during the brutal late stages of a game development schedule, you may have alphas with many components yet to be implemented, betas that still have game-breaking defects, or major revisions that have yet to be incorporated into the game. Essentially, it might be more accurate to say that these versions are "milestones" in the development schedule.

The *RE7* development team, of course, had alpha and beta versions that functioned as goalposts as well.

They had also made a pre-alpha.

The pre-alpha, as the name implies, is a stage that precedes the alpha [the definition of the version will vary according to game makers]. Ideally, it should allow for the game to be played from beginning to end, even if some enemies or items are missing.

On November 25th, 2015, the development team had more than a hundred members, and development of the pre-alpha stage was about to get intense. This was also the deadline for the pre-alpha data.

This data would be edited while the team worked on completing the pre-alpha by mid- December.

Kawata felt this was the perfect time for interviews and asked me to come. So, on that day, I went to the *RE7* development floor.

First, at 9:30 a.m., each team had their morning meeting for five to ten minutes. Not one employee seemed to come late

to one of these standing meetings, where they discussed what they planned to do that day and any current problems.

Incidentally, I worked for a number of game makers myself in the past, but none of them were up and running at 9:30 a.m. to the extent that Capcom was. Game makers—especially "development teams"—generally seem like the kinds of places that get into gear at night, but that wasn't the case at Capcom, at least this development floor. Even before 10 a.m., they already seemed productive.

At 10 a.m., following standing meetings and the leaders of each line went to the conference room for another meeting. The meeting started off with the following words from Kadono and Nakanishi.

"The world ends in just seventeen days."

"I don't feel like doing anything anymore. Let's wait for death."

They looked so dead serious that even I got worried when I heard people around me asking if they were okay.

This day, Kadono lead the meeting, Nakanishi explained the important points, and Chi

065

kept the conversation going. A series of issues were reported.

If you test played what had been completed at this point, you'd run into defects right from the prologue. It was discovered that the wrong version of some data was swapped in.

It was the deadline for the pre-alpha's data, but not everything had been finished in time. It was reported that the broken parts had been reverted to the last functioning version—this was done for a lot of things. Also, the tasks they planned to get done that week were halted at 85% completion. The remaining tasks needed to be organized.

Later, I actually played that version of *RE7* from this time.

The constant barrage of frightening elements certainly did shock me more

times than I can remember. This is how Takeuchi's concept "narrow, yet deep" *Resident Evil* manifested itself.

But on the other hand, putting aside the bugs that were there because it was an early build, it was just as we discussed in the meeting. We weren't able to feel a solid concept for the gimmicks and traps; it felt like they were there just to waste the player's time.

The *RE7* development team had obviously noticed these flaws as well. In particular, the line of flow was seen as a big issue.

At this stage, there were many occasions where I was forced to randomly wander the mansion. The game was dangerously close to feeling like a chore to play. Also, many problems were evident in the combat, which felt monotonous. It all boiled down to simply shooting the

enemy's weak point while using healing items when necessary.

There were lots of problems, and each line was instructed to make several alterations. I should note how the *RE7* development team reacted. When given these instructions, they hardly complained, instead, they agreed those alterations would be for the best. Takeuchi told me the following:

"When you're working in teams, I think you'll sometimes end up being assigned unpleasant work. That's true for every product. The important thing is to have a team fundamentally willing to do the work necessary to make a good game, regardless of whether that work is unpleasant or last-minute. The key is to imbue the team with that attitude as much as possible. That's why Kadono's rule about always properly observing iterations is so highly effective. I think it created the team attitude we were after."

In my personal opinion, the *RE7* development team had two major unique attributes. One was that the environment allowed for each individual member to test a wide variety of things. This was due in large part to the asset-based development capable *RE* Engine and a well-structured team.

And the other was that they made sure to leave time for going over and solving issues in the schedule. Those periods of time were called iterations. The team most certainly possessed the drive Takeuchi had described, the willingness to do what was necessary to create a good game. In fact, *RE7* was about to improve dramatically.

It was March 2016.

I was shocked by the dramatic changes I saw when I played the latest version of the game. One notable difference was the boss fights. The garage battle I mentioned in "Insider Report IX" was nearly complete. If you want to know what shocked me about it, you can find out by playing the game.

The issues that had previously forced the player to wander about aimlessly had been

significantly improved. For instance, even if the player had to go back down the same route multiple times, something unexpected might happen just as the player had been lulled into a feeling of false security. It was no longer possible to let your guard down for even a second.

However, there were still problems. The biggest problem the team had at the time was the latter half of the game to final stage. The idea was for the action to intensify as the player approaches the climax, but according to Takeuchi, they went a little overboard.

Basically, a lot of enemies started to appear and bullets became plentiful, so it turned into a game about blasting your way through foes. To make it easier for the player to act, more open areas featuring foes were added. This was a clear departure from the "narrow, yet deep" concept.

The game needed a dramatic, large-scale revision. However, the fact that this portion of the game needed serious changes didn't particularly come as a surprise with leaders.

"The latter part of the game was finished in April of 2015. It had been touched up a bit since then, but we had also intentionally decided to put off revisions for later. We decided we needed to perfect the beginning and middle parts of the game that formed the core of *RE7* before moving on to the latter half of the game. It wasn't until we really understood what kind of game *RE7* was that we began to have ideas for the latter half of the game. 'What is *RE7*?' This was still being figured out even during development of the middle of the game, so there were times when individual elements would be disorganized or the items would be poorly balanced. The plan was to finish up with the middle section first and then move on to the end. Nobody actually said it at the time, but there was a feeling that we all wanted to focus on the middle of the game first," Kadono said.

Ultimately, it was Takeuchi's bold suggestion to "flip the stage over" which dramatically improved the latter half of the game.

The changes were expected to be a lot of work, but the entire staff understood the importance of the task at hand, so they went about it quickly.

The only problem left was that the beta was scheduled to be completed in April 2016. That left the team just one month to flip the stage over and remake the latter part of the game.

That's when a high priority goal was added to the schedule. Normally, this wouldn't be

the time for significant changes. But for the sake of making a quality product, there were parts of the latter half that had to be altered. Takeuchi said the following.

"We were determined to keep working right up until the deadline to make the product as good as it could possibly be, so nobody complained about how late in the process this was. If it'd make things better, we'd do it. We all worked on every little detail right up until the last minute."

But Kadono, the schedule manager, and Kawata, the budget manager, were terrified.

"Ultimately, we used two months that had been set aside for brush-up, so we somehow managed," Kadono said.

Kadono's responsibility was to schedule progress. On the other hand, Kadono was also a game creator, member of *RE7*'s development staff. If it would make the game better, he wanted it to happen.

"I knew the latter half needed changes, so I told Takeuchi myself that, even though there was only a month until the beta deadline, this was the only time to do it." [laughs]

The schedule was important, but the need to make a good game was even more important. Kadono and the P.M.O knew better than anyone just how little time was left, but it was the P.M.O itself.

And while Kadono was in charge of managing time, Kawata was in charge of managing money. According to Takeuchi, "Kawata was like the grandma who is nagged by her grandchildren."

"It was like his grandchildren were asking for pocket money, so he couldn't turn them down." [laughs]

Regardless, the unified team continued to work hard as the deadline for *RE7* grew closer.

065
Exterior of the shipwrecked vessel.

066
Photo of the crew of the LNG tanker.

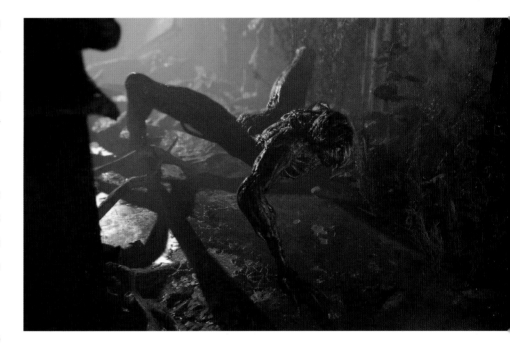

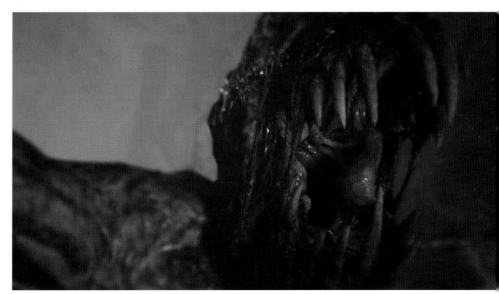

INSIDE REPORT

XIV

THE FUTURE AFTER *RESIDENT EVIL 7*

This is a story from the spring of 2016. As I mentioned in the last chapter, despite being just about to reach a major development milestone, completing the beta, the *RE7* development team was throwing out many ideas and doing lots of revisions. It was perhaps because of that situation that Kadono declared:

"We're extending beta release completion time by two months! The gold master's got to be done in October! The deadline cannot be prolonged. Plan to have all work finished by then! Everyone, please understand!"

However, despite that declaration, he wouldn't hesitate to push the deadline back. He assumed an unexpected situation to come up beforehand and secured a buffer on the work schedule by improving the efficiency of work tasks in advance—but even this schedule had used up all its available time. Either way, the staff also wanted to aim for an October completion date. As a manager, Kadono felt it was his responsibility to make this declaration.

But right after he said this, Takeuchi mumbled the following, almost like a prophecy:

"I feel like there's still something more."

And it turned out just as Takeuchi said. The start of it was mainly due to a certain event held in June.

It was the morning of June 14th, 2016. The team was trying to work through all the necessary changes. Now that we're on the "Inside Report XIV" chapter of this report, let's return to a topic from the first chapter. Yes, E3. It was the day *RE7* was finally announced.

The *RE7* team was naturally restless. The most restless of them, surprisingly, was Takeuchi. He only watched from Japan, but people saw him pacing back and forth in the break room all day, asking himself if everything would turn out alright.

At 9:30 a.m., while the E3 conference was being broadcast to the entire world, *RE7*'s trailer began to play at last. Takeuchi and Takano had put most of the trailer together themselves. Takeuchi outlined what he wanted to show, and Takano as art director worked it out.

Takeuchi had several goals in mind.

"I thought it'd be best not to say it's a *Resident Evil* game until the end. I wanted to make them think 'What's this game? Looks awesome,' and then do the reveal. But I even told Takano it was probably a gamble. There was no way of knowing how the audience would respond."

Their gamble went as I described in "Insider Report I." Gamers around the world reacted to the trailer with shock and awe, and the demo released on the same day was praised as "truly scary."

After the announcement, Takeuchi changed. The worried look he had in the morning disappeared, and after calming down from the joy and relief of being accepted, hearing the cheering when the title was announced, he started to think about the response of *RE7*.

And due to that, even at the point when we were readying the already two-months-late beta, we were still improving and fixing *RE7*. The response at E3 and the expectations of the fans pushed the objective of the entire *RE7* team one rank higher. The demo released simultaneously with the announcement, *Beginning Hour*, had multiple version ups planned from the start, but the idea of "making it even better" just naturally came up between our members, giving us even more to do.

067

"The opening scene was a bit hard to understand, so why don't we try changing it up?"

"Then what if we changed that too?"

"Uh, at this stage in development? If we do that, this scene later on in the game would be meaningless."

"Isn't it kind of late for all this?!"

Several such conversations happened, and they weren't all from Takeuchi or Nakanishi. Much of the staff submitted ideas for how to improve RE7.

Of course, it was also obvious that the staff was concerned about the increasing amount of work. On the other hand, though, they all felt they had to do what was necessary to make the game better, so they maintained high spirits and worked quickly.

Then, October finally arrived. Resident Evil 7's gold master was finished and the development floor was filled with cheers.

As the writer, that's the line I wanted to end this report on. Especially because "The Birthday of Resident Evil 7" is the chapter title I chose for "Insider Report I." I had

initially planned to call this chapter "The Completion of Resident Evil 7," but unfortunately, I couldn't.

The schedule of RE7 is favorable. It's not a reason.

Usually "Triple-A" games, or games produced by mid-sized or major publishers, are released on numerous consoles and platforms. Therefore, PS4, Xbox One, and PC versions of RE7 were scheduled.

RE7 wasn't released in Japan only, so there's a need to prepare masters for each

region. There were also the updates for the demo and the post-release DLC, meaning that we had the workload of "types x regions." When we say master-up, there are actually countless amounts of masters that exist.

There was no single event where every staff member finished at the same time and cheered.

I had Nakanishi show me the schedule in autumn 2016. There was some sort of deadline every week. At the time, the gold master data had been sent to makers for approval. Once it was approved, work on the retail version of the game would be over. But if any irregularities were found, completion date would, of course, be pushed back. This was also when work was really getting started for the sales promotion division.

"I can't say it felt like we were done," Nakanishi said.

Although those were Nakanishi's words, many members of the staff repeated them to me. They were unlikely to get a break-even after the game's release. However, Nakanishi also had the following to say:

"It's a relief to know we're sending the game out confident that its quality is up to snuff."

I actually heard this from many staff members as well.

For example, Kadono, the project manager, said the following about his feelings around this time.

"If you look at the schedule we first submitted to the company, we mostly met it, so I'm very pleased with that. I honestly wasn't sure about the revisions we did in June." [laughs] "But we did RE7 the management we wanted to do it, and we ended up following the schedule in the process. Not only that, but I think RE7 came out very well."

One of the project's art directors, Toshihiko Tsuda, had the following impressions:

"It was a highly anticipated title from the start, so just finishing it was relieving. Especially in RE7, we were able to create something different from the Resident Evil series up until now, both game-play-wise and graphic-wise. As a game creator, I can't help but feel overjoyed; as an art director, I'm very satisfied to complete the objective of depicting horror from an artist's point of view without compromising. There were a lot of new things we experienced for the first time, such as new hardware and new systems—but in the end, I feel rewarded to be able to release something that I'm satisfied with."

The two both expressed satisfaction toward RE7. Despite their different positions, they were able to say that because they felt they both did their best and were satisfied with the results.

In my personal experience, there was one thing I always noticed when stepping onto the RE7 development floor. The average

age of the staff was remarkably high. I've heard it averaged around thirty-five years or older.

The RE7 team had a high number of members who had at least ten years of game development experience. They'd been involved not only with the Resident Evil series but many others. And these people were uniformly satisfied.

Of course, I'm not going to say this means RE7 has to be a great game. That's up to gamers around the world to decide. But it can't be easy to make a game that veterans like these could be confident in—there's no doubt that RE7 is one such game.

This is another tangent. I played RE7 a few times throughout its development for these reports and I was scared multiple times on each occasion. I even screamed in the middle of playing so many times. (The staff of RE7 development team within earshot noticed, with evident satisfaction.)

Of course, it was more than just scary.

Using your limited weapons effectively while taking on traps and trials provided a sense of satisfaction. The intense joy you feel when you're running from a powerful creature and you finally find a shotgun is classic Resident Evil. (It's a great model change.)

Finally, the end of "Insider Report XIV" has approached. Let's remember Takeuchi's two goals mentioned in "Insider Report I," which were noted while developing Resident Evil 7:

1. Make good stuff.

2. Construct an efficient developmental environment and teach the next generation of talent.

I think the first point's results are already clear. They did everything they could to make a satisfying product. In the long run, will it be a success or failure? Gamers will decide.

Then what of the second point?

The efficient developmental environment part should go without saying. The RE Engine enables high graphic expression, allows for each individual staff member to get involved in many parts of the development, and makes it possible to handle a high-end videogame while working within short iterations of time. The improvement in developmental efficiency was clear, and it would have big consequences.

For one, it means shorter development schedules.

But more importantly, it leaves more time open for trial and error, final preparation.

When speaking with developers at Capcom, I couldn't help but feel that these people are craftsmen. They would never hesitate to do something that would improve their work. If you think about it, anything you do first requires you to be up to the challenge. I don't think unique game series like Resident Evil, Monster Hunter,

068

or *Ace Attorney* could have been made by anyone but Capcom. Given more trial and error time, final preparation is a big plus for a company of craftsmen like Capcom.

The *RE7* team was organized in a flexible way and utilized "Agile" and "line" software development models. They had thorough iterations over which they reviewed and revised the game. This uniquely structured development experience will surely be of great value to Capcom in the future.

Of course, it's not as though simply adopting Agile or the line model will improve efficiency. This developmental structure would never have come about in the first place if not for this particular project and the *RE* Engine. Were it to be used by another team, it would likely need to be adapted to their needs. However, that can't work without experienced staff. So, what of that point?

When I asked Takeuchi, he had a fascinating answer:

"I was actually just checking the contents of a demo final update. The staff made it without any input from me, but it turned out incredibly well. They understand *RE7* and what they need to do to make the game scary or fun, so I can proudly say they've got it."

There's no need to pay too much attention to surveys or player input. Instead, make sure your game has a strong core, make sure the whole team understands it, and

perform trial and error to make it. However, there must also be periodic reviews, and if it becomes necessary again later, extra time for trial and error.

There was also the attitude that anything was worth doing if it'd make the game better. The entirety of the *RE7* team believed in that idea. Developing *RE7* most certainly educated and developed the next generation of talent.

But Takeuchi didn't forget to add the following.

"That being said, they'll probably make the same mistakes they did on *RE7* over again." [laughs]

Takeuchi went on to explain that it is because game development isn't so simple.

"Even educated people repeat their mistakes. That's what makes game development interesting. But if these guys repeat their mistakes, they should be able to recover fast and know how to handle it. Some of *RE7*'s staff has joined the team for the next project after finishing and that already is having great results. Most of the team for the next project wasn't involved with *RE7*, but when the *RE7* staff joined, it strengthened their "core," allowing them to not be too scared of the users' voices, and they started to think outside the box. Being stimulated by *RE7*'s staff, the atmosphere of the entire team for the next project is a good one."

Slowly but surely, a revolution in game development ten years down the line is sprouting.

Of course, there will always be a need to streamline the process and implement new technology. But mentally, the stage is being set.

Lastly, I asked Takeuchi about his future goals.

"I want to make an even better survival horror game. You could say *Resident Evil* is already almost synonymous with survival horror. When the time comes to make another *Resident Evil* sequel, I want it to shock people. We did a lot of things like the announcement and all with *RE7*, so the bar for surprising people has been raised pretty high, but around the time when everyone forgets, I'd like to do it again."

It may seem too early to say, but once *RE7* has been released, Capcom will naturally have to think about what comes next. And when that time comes, the developers will most likely be overwhelmed with intense pressure yet again. But just as they did with *RE7*, and thanks to their experience on *RE7*, there's no doubt they'll shock the world once more.

067
The abandoned mines connected to the Baker residence. Connecting the Bakers' home and the shipwreck, this place is the key to unlocking the beginning of the story and the truth.

068
Alan, who worked as a covert operative aboard the LNG tanker with Mia.

COLUMN III: MOLD'S TOXICITY

TEXT: DENGEKI STRATEGY GUIDE EDITORIAL DEPARTMENT

Some mushrooms are well-known for being poisonous, but even familiar molds can produce unbelievably deadly toxins. Called "mycotoxin," the toxin that mold produces has been the subject of worldwide study for many years. Mycotoxin was discovered in England in the 1960s when an entire house of turkeys died after being fed moldy peanut meal. That lethal poison was a mold called *Aspergillus flavus*. *Aspergillus flavus* produces aflatoxins, toxins that cause acute liver failure and induce cirrhosis and liver cancer. *Aspergillus oryzae*–the koji mold used in Japanese sake brewing– is biologically related to *Aspergillus flavus*. They are almost genetically identical; however, koji mold is miraculously missing the gene crucial to producing toxins. That is why its scientific name is *Aspergillus oryzae*. Getting back to the poison in mushrooms, some Amanitin mushrooms like *Amanita virosa* and *Galerina fasciculata* contain the strongest toxins. Just a few milligrams is fatal. (A single mushroom produces enough toxin to kill 2–3 adults.) Thus, it may be good to consider molds in general as being poisonous. That poison is harmless until it reaches dangerous levels and can be detoxified and metabolized quickly, so there is nothing to be afraid of. (However, it may be good to regard moldy, dry grain as dangerous.)

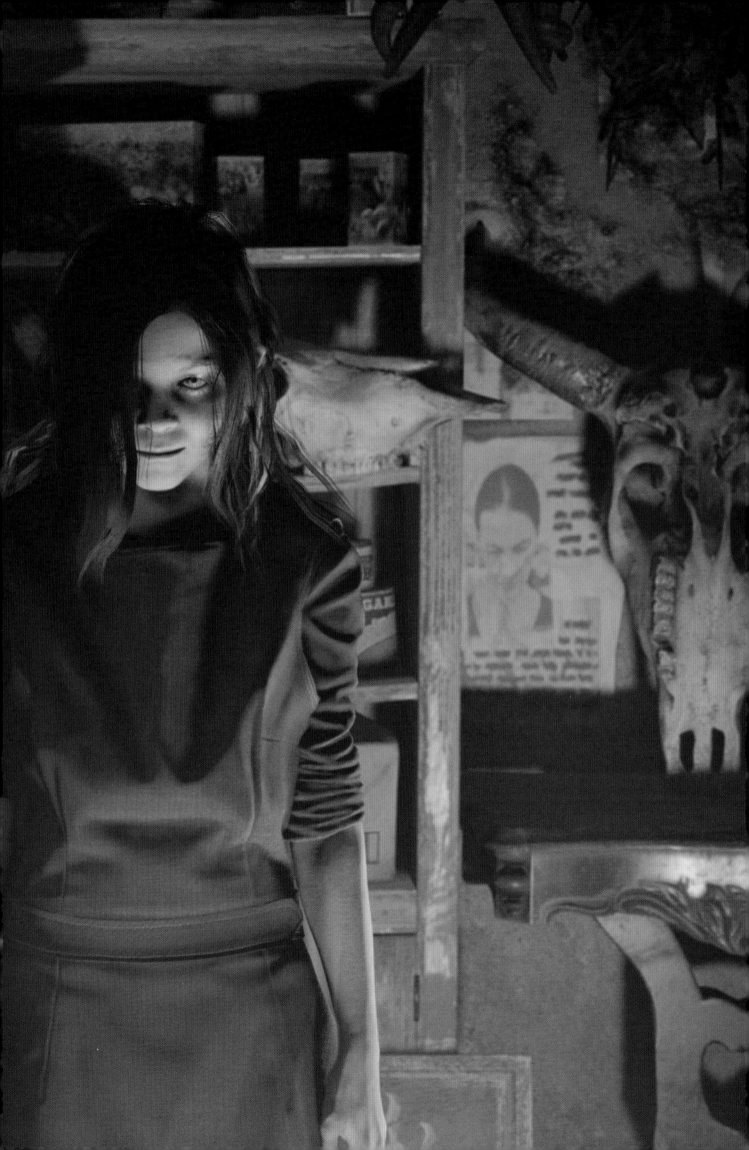

INSIDE REPORT

XV

PROMOTION: A DIFFERENT CHALLENGE

As detailed in previous entries of this inside report, development work on *Resident Evil 7* was approaching its end in the summer of 2016. Although many members of the team were in no position to relax at the time, including the DLC development team and the debug programmers, not to mention Producer Kawata, and Director Nakanishi, members with nothing left to do were being reassigned to development teams for other games.

Even so, there are team members who only get genuinely busy when the game is nearly complete. Generally known as the marketing or promotion staff, these team members work in departments related to sales.

No matter how good your product is, you need to inform a lot of people of its existence and value and persuade end users to part with their hard-earned money in order to sell it. *RE7* was no different from any other game in this regard. While the *Resident Evil* series name is known widely enough, that doesn't change the fact that people won't opt for it if they're left in the dark about it. This is where the sales team's real battle begins. We naturally tend to look toward the development team when we think of games but during this chapter, I'd like to focus on the sales team's efforts.

Tsuyoshi Kanda, Tsutomu Masuda, and Manabu Okamoto all played major roles in the sales and marketing of *RE7*.

In fact, Kanda has already come up in "Insider Report III." By title, he's listed as the Promotional Producer for *Resident Evil 7*. In short, he is the marketing manager attached to the *RE7* development team. Traditionally, a single producer handles both development and marketing for most games. For the *Resident Evil* series, that would be Kawada. However, handling a global launch across three regions (Japan, the United States, and Europe) in addition to his development work stretched Kawada to his limits. That was when Kanda was selected, with his fourteen years of sales experience in both Japan and the United States. Kanda's role in his position as a member of the *RE7* development team was to communicate the game's appeal to the entire world.

Of course, Capcom has a dedicated sales department, as well. The section in charge of marketing, advertisement and promotions are called the Sales Promotion Division.

Masuda is the manager of the sales promotion division and took on the role of general manager of global promotion and marketing for *Resident Evil 7*. This position manages all marketing and promotional activities not just in Japan, but on a worldwide level.

Furthermore, Okamoto manages marketing as a promoter. He primarily worked on implementing a variety of marketing campaigns in Japan, the planning of the *Resident Evil* Café and Tokyo Game Show booth, and similar activities.

It was in April 2015 that Masuda and the others in the sales section truly went to work on *RE7*. If you've been reading these reports from the beginning, you probably know what happened right at that time. The team completed the vertical slice and unveiled the game internally at Capcom. It was when the sales section staff first learned what kind of game *RE7* was going to be.

Masuda said of the first time he set eyes on *RE7*:

"At first all of the sales-side staff were terrified. Everyone said, 'What is that?!'" [laughs]

"There were sudden perspective shifts, none of the series' usual characters

showed up, and the visuals were more lurid than ever. I was overwhelmed for a little bit, realizing that I had been there at the moment that *Resident Evil* was reborn. From a sales perspective, within Japan we recorded over one million units sold for *RE6*, the previous entry in the series. There aren't many games like that, so we were extremely nervous about whether or not casting aside the conventional approach would work out."

As head of the marketing division, he had the same reaction as many of the development staff when they heard Takeuchi's ideas. However, Masuda added the following.

"But I definitely got sucked into it as I watched, and found myself thinking that 'this looks fun.' Since scary fun is the real heart of *Resident Evil*, we needed to welcome the challenge of creating it. And deciding how to get game fans around the world to accept this challenge from the development team let me show my skill as a promotional manager. I also thought it was fun working to find new, unheard-of ways to show it off."

The development and sales teams for *RE7* went on to work together in this manner, refining a publicity strategy that communicated *RE7*'s appeal.

Initially, the concept for promotion was "how to communicate 'the value of experiencing *RE7*' to fans." The sales managers had all sorts of emotional reactions when they saw the newly-reborn *RE7*. They felt it was scary yet also fun, and that it made them want to tell others about the shocks and excitement. Communicating this "experience value" (the sort that makes you want to tell the story) would of course give end users a reason to purchase *RE7* for themselves. However, it would also lead them to tell the next person down the line about the "experience value" of *RE7* in the same manner.

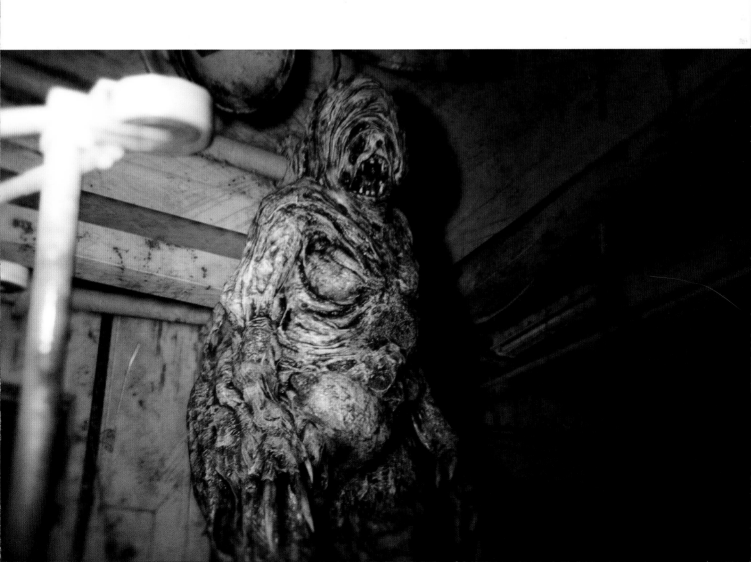

Their first act at this point was to make certain that the staff representatives for all countries understood the game better than anyone else. They considered when and how to communicate what kind of information for all sorts of aspects of the game, from the signature horror and the fun of triumphing over it, to the intricately plotted story, the striking visuals of the Baker house, and more. In *RE7*, the team placed particular emphasis on what kind of game the player would experience. "The unknown" is a vital component of the horror in *RE7*. They had to take exceptional care to eliminate any elements that might spoil twists or scares in order to allow players to enjoy their first time playing through in an ideal setting.

E3 2016 seems almost symbolic of their efforts. As mentioned in "Insider Report I," they kept the *RE7* announcement a secret until the bitter end, and successfully maximized the surprise by distributing the demo (*Resident Evil*: Beginning Hour) on the same day.

As a result, many fans were shocked to see *Resident Evil* reborn, then went on to play the demo. From there, they spread their personal experiences and the news that "it was really scary" on social media. It truly went exactly as Takeuchi and Masuda had intended.

Naturally, they also continued their extreme efforts to avoid revealing any spoilers that might touch on significant sections of the game. From the initial Beginning Hour

demo, the setting in a creepy mansion and the appearances by a disturbing family (including Jack Baker, whose nickname "Family-Puncher Man," which was catching on even at the time) were widely known. Yet all other information was strictly suppressed. While showing that this was a *Resident Evil* completely unlike anything that had come before, they kept any information that might reveal the full picture a secret.

As I've mentioned in the past, the team took an approach that involved several version upgrades for the demo, *Beginning Hour*. In the 1.0 version they first distributed, questions like "Is there a way to escape?" and "What purpose does the mysterious Dummy Finger item serve?" were major topics of interest among players. And anticipating that topics like this would come up, the *RE7* development team was prepared. Each time they updated *Beginning Hour*, they answered numerous questions while generating entirely new ones. And just by showing the fans glimpses of *RE7*, they continued to build excitement and anticipation for the game. Even as a footnote to the main story, *Beginning Hour* managed to achieve a record 7.5 million downloads by February 2017.

But there were also negatives to this method of suppressing information. For example, it's true to say that *RE7* was greeted with cheering at E3 in June 2016, and that it generated a lot of talk at the time. However, that leaves a gap of more than half a year between *RE7*'s announce-

ment and its launch. Over that time, it was extremely challenging to keep interest in *RE7* simmering while using this method of releasing limited information in installments. New games are announced and launched every day, competing for gamers' attention. In fact, I am told that there was backlash against this promotional method even from overseas distributor subsidiaries within Capcom.

Capcom held a global meeting of sales managers at its head office in Osaka in September 2016. It was a huge gathering, including Takeuchi, Kawata, Kanda, Masuda and the others as well as Capcom distribution managers from Europe and the USA.

At the meeting, each region reported on its current situation in turn.

The number of pre-orders for each region was fairly good considering that they were still four months from launch, but it still wasn't high enough. While user opinions on social media showed high interest and anticipation for *RE7*, they hadn't managed to give people a compelling reason to pre-order a copy. And one major reason for this was that they didn't know all of the details about the game. While this method of hiding information had done a great deal to generate interest in *RE7*, there was a chance that it wouldn't be able to maintain that interest.

Of course, a counterargument formed with Takeuchi and Masuda at its core. They had known that something like this was coming

since they first settled on the promotional method. Fans were busily imagining and debating what sort of game *RE7* would be; this was exactly as the team had anticipated. They would create promotional videos just as planned, and start large-scale hands-on demos (preview sessions for media) and television commercials in December. That left October and November open, but they were open to ideas.

In actuality, they implemented one plan after another to spread the word about *RE7*'s "experience value." The "*Resident Evil* Ambassador" program seems to have been a representative example of these efforts. This was a program to recruit fans who would actively spread information about *Resident Evil* on their blogs, Twitter, Facebook, or other social media. They would prioritize sharing of information with these fans, give them invitations to demo events, and provide guidance on exclusive campaigns and other efforts.

Information on most games is limited to official websites and anything published by the gaming press prior to launch. Under the *Resident Evil* Ambassador program, a portion of the fan base effectively took over this role. It was a very modern promotional method for an era when social media is becoming an increasingly vital part of our lives.

They also executed a plan to reveal ten short videos—roughly ten seconds in length—to the ambassadors. The videos were shared one by one. One video

revealed glimpses of the game's setting and enemies, spurring interest; another focused on a theme of "the shotgun in the box," showing the detail typical of *Resident Evil*.

For each video, they aimed for something that the fans would spread and communicate with others.

Meanwhile, an unexpected miscalculation began to make its presence known as they approached the end of 2016. Via distribution of the new demo and the *Resident Evil* ambassadors, they had definitely succeeded in informing fans that the game's horror was second-to-none. However, they had begun to generate too much buzz about that same horror. Apparently, they saw comments stating that "it looks too scary, so I'm not going to buy it after all." It makes sense. No matter how popular or fun a thing is, some people will be hesitant about it if it's too scary.

But in *RE7*, the savage horror heightens the struggle of survival and generates an unprecedented level of entertainment value. The problem was that they hadn't fully communicated half of this appeal.

At that point, they revised their objectives. They retained the policy on avoiding spoilers in order to ensure an ideal first playthrough for everyone. But in contrast, they changed the focus of the information they pushed to the forefront. Starting in December, the theme they aimed to communicate shifted from "experience value" to "sharing in the sense of fun." They

did everything they could to spread the impression that you can't stop playing despite how scary the game is, such as having famous YouTube personalities play the game and providing ambassador members with videos featuring survival, specifically. The graphic of Ethan holding a gun, published early in 2017, is representative of these efforts. In effect, "resisting horror" was the linchpin of their efforts.

The promotional efforts finally reached their climax as the launch date drew near. Acting according to their objective of getting people to encounter *Resident Evil 7* somewhere every day, they took specific measures such as advertising in train stations and on billboard, as well as broadcasting commercials and playthrough videos featuring famous personalities. They also conducted publicity nearly every day, constructing outdoor locations reminiscent of the Baker house and aiming for effects that felt close to home for the fans. They wanted to generate a festival-like atmosphere for *RE7*'s imminent launch.

One joint effort with the hardware manufacturer for PS VR became a major topic online. In it, ghost story king Junji Inagawa tried out *RE7* and the *Kitchen* demo. Inagawa started out bold, boasting that "I've visited scary places, so a mansion isn't going to scare me." But he didn't hesitate to praise the game once he played it, stating that "virtual reality is no easy matter." This carried weight when coming from the king of ghost stories, and it generated a lot of talk on social media.

Then came January 26th, 2017, and *RE7* finally went on sale. It was the day that gamers around the world had been waiting for.

Previously shrouded in secrecy, *RE7* was finally fully unveiled. Most readers likely already know the outcome. The voices of fans who had experienced *RE7* reached a crescendo on the internet. It was scarier than they had anticipated. But it wasn't just scary—the fear itself served to heighten the sense of relief on surviving a risky situation and the thrill of defeating enemies beyond that of any previous game. And players found themselves unable to put it down, drawn in as they were by the story that only reveals itself with progress as well as the finely-tuned game balance. They found that *RE7* was exactly the sort of survival horror they had been waiting for; that it was a new era of *Resident Evil*.

Then the game's value began to show numerically, a matter of the utmost importance. The day after its launch, they made an official announcement that it had shipped more than 2.5 million copies globally. Without missing a beat, it broke 3 million copies by February 14th. Even now, the number continues to grow steadily.

Okamoto told me the following when *RE7* had been on sale for about two weeks.

"Last year, *Resident Evil* hit a turning point with its twentieth anniversary. *Resident Evil* is one of the rare games with players that have grown up over the course of its

history. Of course, I was a bit nervous to take on the challenge of *RE7*, given its reputation in that regard. But now we've actually reached 3 million copies, and I'm proud to see Capcom showing it has the spirit to make bold moves in adapting with the times. I'm sure that development will continue to lead the way in the future, and I just want those of us in sales to continue to communicate their enthusiasm to the rest of the world."

Resident Evil 7 took on its final form thanks to the challenges that the Development team issued with Takeuchi at its core. But it wasn't easy to get countless fans to accept it, along with its major changes from past series entries.

Masuda and the others in sales were responsible for creating and maintaining an environment in which the newly-reborn *Resident Evil* could move 3 million units over less than a month from its launch. To do this, they cultivated a deep understanding of the bold challenge he was issuing and conducted a broad range of promotions based on past experience.

For most products that become major hits, there is a brilliant salesman at work in the background at all times. The challenge that *Resident Evil 7* posed is only meeting such near-complete success thanks to the trust between its development and sales teams.

069
"Atmosphere." "Atmosphere." Now in the same space as Eveline, you witness a transformation that leaves no trace of the original form.

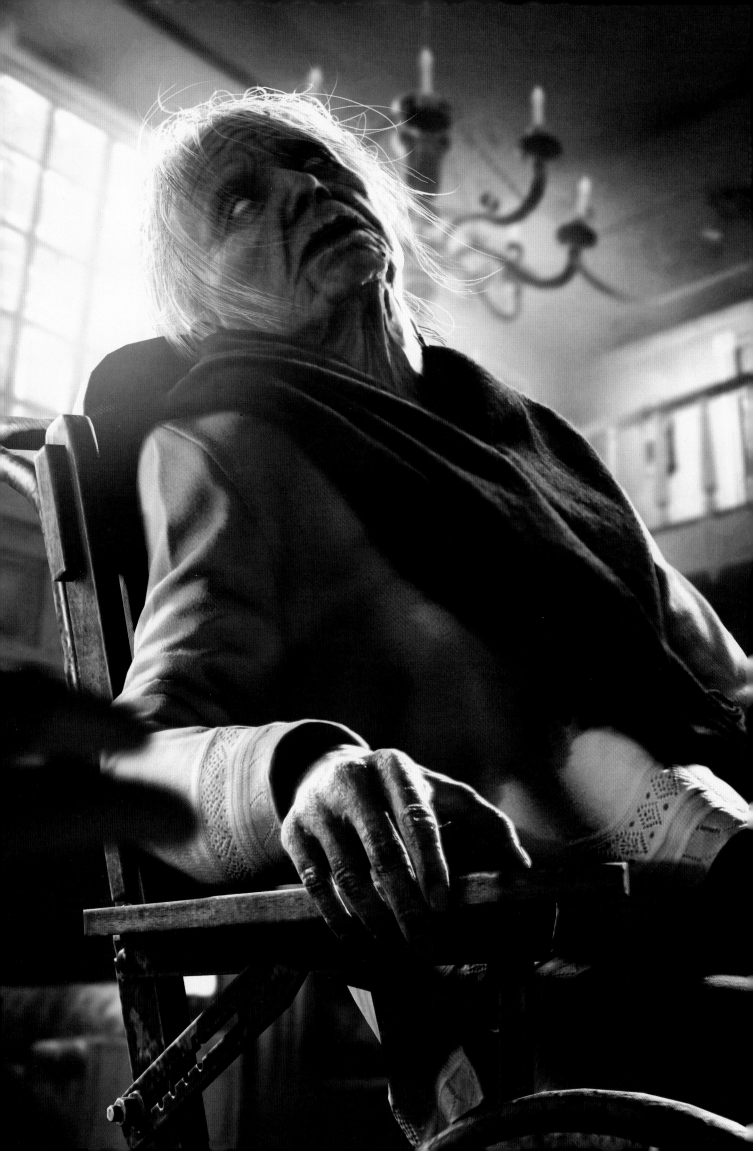

INSIDE REPORT POSTSCRIPT

As I mentioned in this report, what I realized by working so deeply with Capcom was that it's a group of craftsmen.

In Japanese, we have a word that means "the spirit of a true artisan." It means having confidence in your skills, a specialty, and an honest quality to what you make. This spirit is not limited only to games. Every creator possesses it to some degree, but I felt it was especially strong at Capcom. They were confident about their talents and continued to make many games that they knew were fun. This is true even of the first-generation *Resident Evil*, *Monster Hunter*, *Street Fighter*, and *Ace Attorney*.

Of course, not every game has received the highest praise. What they make are goods. And their artistic spirit can sometimes get in the way of selling these goods. Or conversely, they become so fixated on selling the product that they are unable to make an artistic game.

In the numbered *Resident Evil* games, that may have been the case during the planning stages after the sale of *Resident Evil 6*. As touched upon in the report, there was a period of turmoil in the development of *Resident Evil 7*. But thanks to the plan started by Jun Takeuchi, all members got on board and cultivated an environment in which individual techniques could be freely used, and thus an amazing seventh installment was completed.

A steep jump in development costs for Triple-A titles is inevitable. In order to recover huge development costs, both core and other users must buy the game. And it's not hard to imagine making artistic games becoming difficult without this.

During the production of *RE7*, however, they did not exceed the budget (although the budget itself was far larger than the readers imagine) and endeavored to make a new and artistic Triple-A title. They succeeded. As a fan of games, I will pray for Capcom to forever make games that shock the world.

Finally, a word of thanks.

As a writer, I don't have much talent outside of novels, so this is my first time doing a job like this. Nevertheless, with my love of games and experience having written novels about games, I got a job from Dengeki PlayStation as a column serialist and eventually got the job to write the "Inside Report" sections of this book.

Furthermore, without the help of Dengeki PlayStation Editorial Department, not even a single page of this book would be seen by the world. I'm especially thankful to Mr. Shirahata of the Editorial department. He was bustling about between the external writer, Dengeki PlayStation Editorial Department, and Capcom. It's hard to imagine how difficult such a job was, but thanks to his support in these articles, we were able to finish the entire report.

Last but not least, the situation surrounding the publishing industry is extremely tough, but as long as there are editors like those at Dengeki PlayStation, they've reinforced their belief that it can continue to be a reliable game media in the future.

March 2017, Toru Shiwasu

Toru Shiwasu/Novelist since 2003 via Sonic Team. His representative works at Kadokawa Corporation include Our Game War *(Dengeki Bunko, eleven volumes) and* Lawless Lawyer *(NOVEL 0, three volumes published).*

070

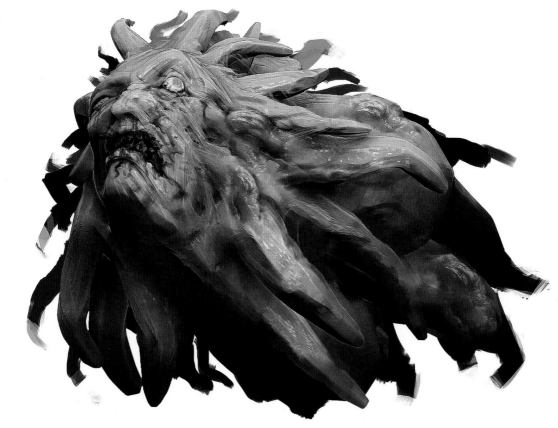

071

- Looks like it's being pulled and stretched.
- Surrounding tentacles look like hair.
- A little mold leaks out.
- Added small tentacles to make it lively.

072

073

074

075

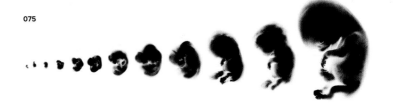

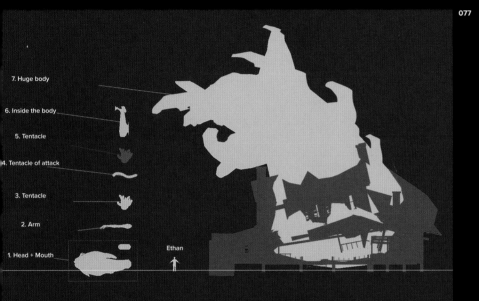

7. Huge body

6. Inside the body

5. Tentacle

4. Tentacle of attack

3. Tentacle

2. Arm

1. Head + Mouth

Ethan

070–071

Eveline when she loses control. An array of emotions appear on a rapidly aging face. It looks as if she is releasing pain and intense malice.

072–073

Front and side view.

074–076

Some documents about Eveline. They show her artificial birth and development.

077

A document showing size comparisons to Eveline's form when losing control. In the center of the diagram stands Ethan.

078

Eveline, who tried to create and control a family. Mold with a will of its own, or a human child born as mold. Which is these is her true form . . . ?

There are man-eating molds in the world. The molds cocci-
dioidomycosis, histoplasma, and paracoccidioides normally
decompose bat feces in the natural world. But if they enter the
lungs of humans just once, they will start decomposing their
internal organs. Moreover, because they are molds active in bat
feces, they do not weaken within the bodies of humans. In some
cases, they decompose organs one after the next until the human
dies. (Though in majority of the cases, people naturally recover . . .)
In actuality, it's thought that several deaths a year are attributed
to these molds in some tropical areas where they grow.

Now then, is it possible to use these dangerous molds as
biological weapons? The current answer is "no." This is because
mold spores themselves are not very strong and could not
withstand the storage time for biological weapons. There are,
however, examples of mold being used as a biological weapon
in the past. It's not impossible to use liquids containing these
bacteria to harm the originally harmless opportunistic pathogens
in people's bodies. When considering them as weapons, perhaps
the more frightening thing is thinking about the mold growing on
crops. For example, an outbreak of the mold that destroys grains
such as corn and wheat would ruin agriculture. Even if
exterminated in an early stage, there will still be great damage
to the harvest.

Column V: Mold Manipulating Organisms

Text: Dengeki Strategy Guide Editorial Department

It's not rare for a mold to parasitize off a living creature, effectively turning them into a zombie. A representative of that belongs to the caterpillar fungus family. As its name in Japanese (literally "winter bug, summer grass") implies, it's active in the winter and dies in the summer . . . The *Ophiocordyceps sobolifera* that grows on cicada larvae are famous. A similar example was a member of the Ophiocordyceps family recently discovered in the South American Amazon. This mold parasitizes off the ant, then controls its movements. Most ants know that molds like caterpillar fungus are their natural enemy. When indiscriminately parasitizing and cultivating mushrooms on ants, it cannot propagate if the sporing mushroom is destroyed or buried in the dirt. To that end, the mold takes ahold of the ant's nervous system and purposefully moves the ant behind a leaf before terminating them—in order to avoid direct sunlight—and then grows the mushrooms. As insect bodies are not controlled by the brain, but rather mostly by the reflexes of their ladder-like nerves, the mold spreads its hyphae to those nerves and inhibits hormones and transmitters that control movement to gain control. There are many cases of experiments in which electrodes are embedded in insects and used to control them with a remote. And it's not just limited to mold like this. While there are many examples of parasites controlling their hosts in nature, there are also molds that control humans. A stringy parasite known as the Guinea worm is one that goes between the human body and water, but causes a burning pain in the feet that can be abated when soaked in water. When the host can no longer bear the pain and puts their foot in the water, the worm will eat through the skin and escape into the water, its body full of eggs. It's a horrible and mysterious system. Fortunately, no molds or parasites have been found to take over the mammalian brain. However, it may just be that they haven't been discovered or have yet to be created. Knowing what you do now about mold, perhaps you will have a renewed fear of the story surrounding Eveline.

079

080

081

082

084

085

086

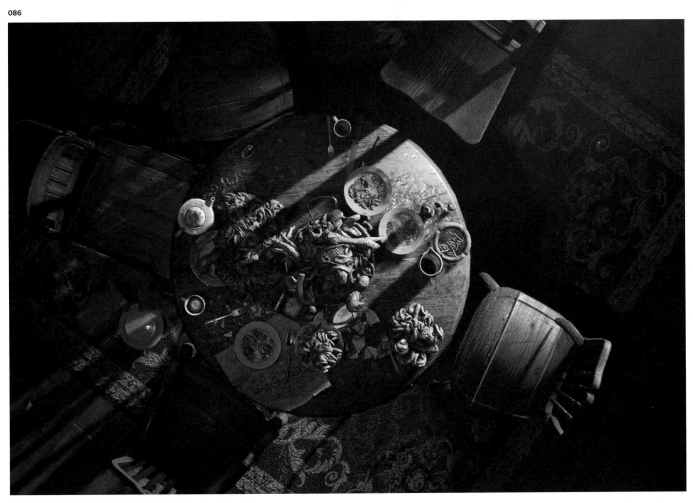

087

088

089

090

091

092

093

094

095

096

097

098

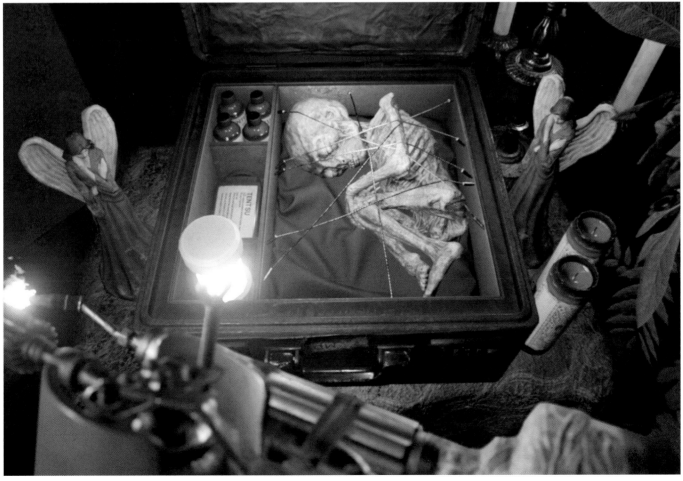

099

100

101

102

OCT.05, 2014 08:37 PM
Mia Winters
Cabin

Masv jh-15al Attd

"Test Subject E-001"

Sea Transport Log - Top Secret

4fdUS-00551/90009
S-VHS

OCT.05, 2014

00:49:00:78

103

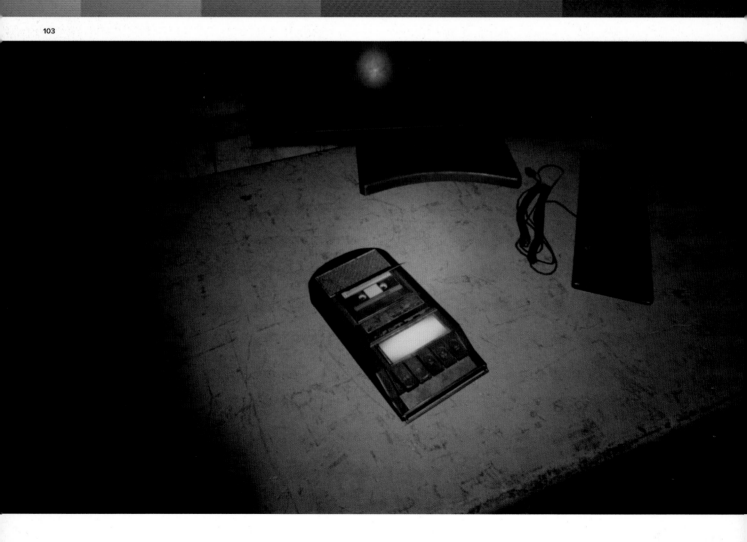

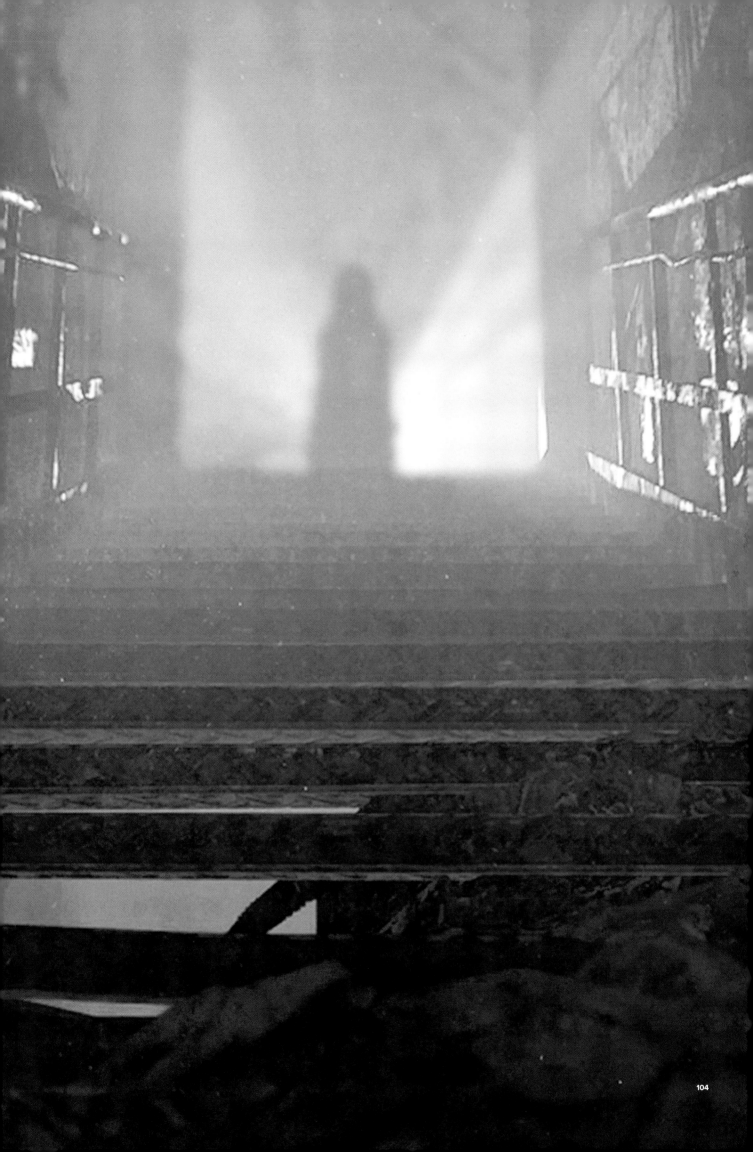

079
The kitchen of the deserted house. A striking contrast of sunlight and shadow.

080
A CRT television and the video deck. White noise is displayed in the analog television.

081
The old photograph of Mr. and Mrs. Baker.

082
A terrifying atmosphere—the inside of the deserted house is messy and dirty.

083
Andre's corpse. He was murdered by the Baker family.

084
The preliminary exploration of the Dulvey Haunted House for the paranormal investigation series *Sewer Gators*.

085
Police patrol vehicle sitting outside the garage.

086
Round table, four chairs.

087
The push dial-type telephone that was common in the United States of the 1970s.

088
Dulvey newspaper—witness information of the ghost.

089–091
Dirty, artificial teeth.

092
Weird dolls on the wall.

093
Fighting with a chain saw.

094
Jack Baker was destroyed. The terrible expression that words are not possible.

095
The old house: a nest of insects and scribbles.

096
The stairs which follow a basement.

097
Marguerite Baker standing on the stairs.

098
Mummy of a child discovered at an altar.

099
Ladder in the darkness.

100
A birthday cake with its candles lit. A card with a message written on it.

101
Lucas Baker gives a provocative greeting.

102
The film "Test Subject E-001," which was left on a videotape.
OCT. 05, 2014 08:37PM
Mia Winters

103
The cassette tape recorder which was left inside a scrapped ship.

104
The silhouette of the girl.

105
At the crack of dawn.

INSIDE REPORT Photographic Memories

[INSIDE REPORT COVERAGE RECORDS]

Finally, I will document the prized materials provided by the development
team and long-term, close-coverage photos from Dengeki PlayStation's
coverage group I received when writing the Inside Reports.

OCTOBER 5-14, 2014
STATE OF LOUISIANA

Capcom's *Resident Evil 7* staff coverage of Louisiana.

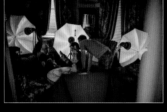

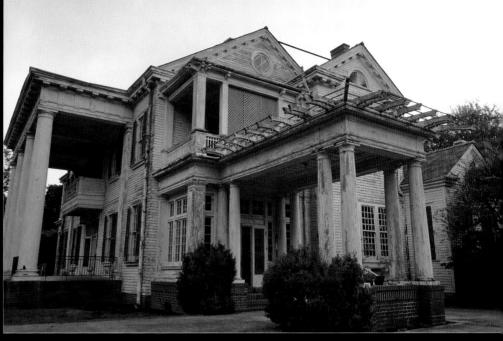

The coverage team visited the state of Louisiana in the American south, facing the Gulf of Mexico.

They went to various places that could be used as reference for the game, such as local residences, plantation houses, marshes, sugarcane fields, and greenhouses. To learn more about the area's distinctive culture, they also headed to voodoo-related shops, abandoned hospitals, gas plants, and barns. The knowledge and materials they gained were deeply integrated into the game.

JUNE 2015 "KITCHEN"

Screenshot of a mysterious project entitled *Kitchen* that players could experience at game events from 2015.

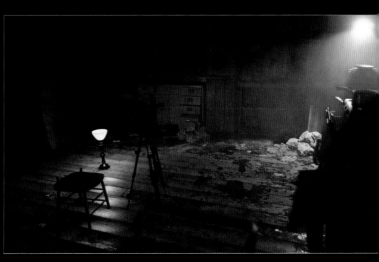

Kitchen was released as a technology demonstration for Project Morpheus at E3 2015. At that time, it had not been revealed that it was demo content for *Resident Evil 7*. On October 13, 2016, it was sold as a PlayStation® VR exclusive for only 93 yen (tax excluded).

SEPTEMBER 2015 COVER THE "VII"

The coverage team heard from Mr. Takeuchi and Mr. Kawata that work on *Resident Evil 7* had started.

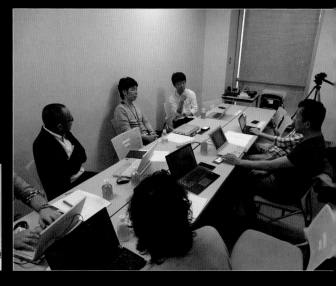

DECEMBER 8-10, 2015 LOS ANGELES "HOUSE OF MOVES"

Records of the motion capture studio "House of Moves" from Dengeki PlayStation's editorial chief Yoshimichi Nishioka's visit.

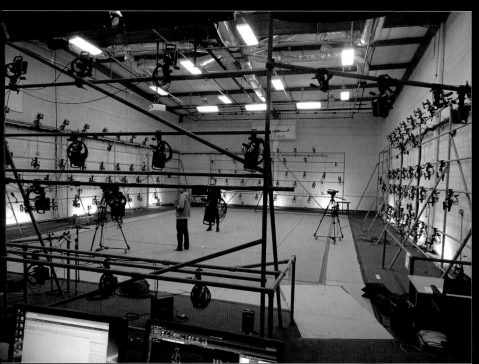

At the site where earnest battles were unfolding, fierce debate over equipment trouble and acting guidance are everyday occurrences. The setup of equipment is especially delicate, and something as simple as setting a smartphone on a bar might incur the wrath of studio staff. The area of capture is inside the pink line (see the top left photo).

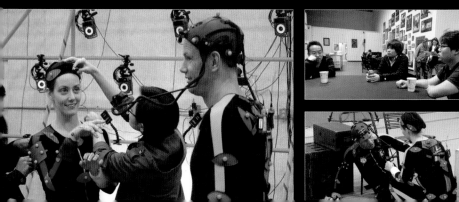

HOUSE OF MOVES, TECHNICAL SUPERVISORS
DJ (Right)

SUPER ADVISOR
ERIC LASHELLE (Left)

MOTION CAPTURE STYLE

In addition to what the development team wanted to do and what we were capable of doing, we placed special importance on the face. How well can someone express facial emotions? This time was especially great because we were able to get a more flexible response by combining the marker method used until now and the blendshape method. The marker method involves marks, or small points, that you attach to your face. These are optically tracked to express the face's shape. Blendshape uses a shape as a base, but doesn't capture actual points. Instead, it captures expressions with a camera and reproduces them in 3D. The two systems couldn't coexist until now, but we had a controller this time that made it possible.

And facial expressions are very difficult. Try to imagine it. Even if you call it a real expression, if it's just a pretty face, even if the expression is correct, is it actually a real expression? Is it the face you'd make if you were afraid in real life? That's what we want to get to the bottom of. (DJ)

We started this job in December 2015, so this is our fourth time filming. I think it might be the same on the Capcom development side, but I can understand what they are thinking and what they are hoping for with each session. We've established a mutual understanding so that we know even the small things they want without having to ask for instruction. I think it was a great harvest for production. (Eric)

WORKING WITH CAPCOM

I'd say that the concepts and game DNA have about the same style at other companies, but Capcom has its own way of doing things. We have about a sixteen-hour time difference between us, so we had to figure out how we were going to make it work. I think figuring out how we were going to communicate or how to respond to the technical parts of the game they were trying to make were especially interesting. (DJ)

I thought that their way of throwing players and characters into a confrontational situation and putting them into a face-to-face showdown was unique. I also thought they were very conscious of the VR version by making it in first-person. It seemed like they made the game assuming that it would be in no way inferior if a Morpheus (PS VR) or Oculus Rift version was made. (Eric) *The software is now compatible with PS VR. Even though things were highly confidential, it seems like their ambition really came across. (Editor's Note)

From a production standpoint, I can say that things were tidy and orderly. Even though we did our preparations and were ready to film, they had the script and other necessary documents prepared beforehand. I've worked with other companies where they say, "Well, what should we do now?" on the day of, so... (Laughs) I got the impression that Capcom was taking the lead in that aspect. (Eric)

During filming, getting two thumbs up from the staff behind the stage as their way of saying that we did a great job was the best feeling. Another impression I got was, whenever a staff member would come over and say, "There's something I'd like to talk about," I knew it wasn't a good sign. The conversation wasn't going to be easy. (Laughs) (DJ)

MOTION ACTOR (MIA)
KATIE O'HAGAN

THE ROLE OF MIA

First of all, I am exhausted as her actor. (Laughs) It was important to have two personalities in equal measure. If I was acting as the normal Mia one day and different the next day, I had to use image training to mentally prepare myself for completely switching gears.

I had to make sure not to mix up the two and treat them as separate entities. When performing, I try to dive deep into that character and concentrate on acting. It's very important to do things naturally and not be conscious of my "role," and to have confidence in my own performance. Acting shy or embarrassed doesn't work. I have to be confident in what I'm doing. Whether I'm transitioning from human to spirit or vice-versa, as long as I perform to the best of my abilities, it will be properly reflected in my character. This was my first time working on a game, and I really enjoyed it.

EXPRESSING CHARACTER

Generally speaking, expressions need to be emphasized. The director advised me to exaggerate more. He said that it's better to act bigger than with a bit of nuance and delicacy. Rather than acting crazy, showing craziness gets the message across. For example, I put in about 30% during rehearsal, but 100% during the real thing. And even though I thought I was giving it my all, the director would always say, "If that's 100%, I want to see 120-130%!" This time, you can see everything from 360 degrees—bodily gestures and postures and whatnot—because of the motion capture suit. I really learned a lot.

RELATIONSHIP WITH ETHAN

Ethan's actor and I were on the same wavelength, so it was really fun to perform with him. But there are a lot of scenes where I had to hurt Ethan, which worried me. Because I would hurt him and he would come back. And then I would hurt him again, and he would still come back. (Laughs) The scene where Mia uses a chainsaw to attack Ethan left the biggest impression on me.

RESIDENT EVIL

I auditioned for the role of Mia this time, but it wasn't a public audition, so I didn't know that the job was for a game and there was no script. All I was told was to come in on the appointed day. The director and actors gathered there for the first time, did the audition, and was so excited to get the role. I didn't understand that it was for the Resident Evil series, but during the filming I found myself thinking, "Could this be...?" At first, I didn't think much more than it being for a Japanese video game. It was a secret until the day it went on sale, so I was anxiously awaiting it. I'm so excited. I think it would be so much fun to go to Comic-Con after its release.

PRODUCER
ROSANNA SUN (Left)

DIRECTOR
NAVID KHONSARI (Right)

WORKING WITH CAPCOM

Including unpublished films, this is our third time working together. But with every title, previous problems are properly improved upon, and we see the other as a trustworthy partner. (Rosanna)

Since we're working on creative content, when we discuss how to do things, we're constantly exchanging ideas. It's never a one-way thing. I think they're a partner who can make a quality product. (Navid)

KEY POINTS

With this job, I think the thing we were most conscious of was the first-person camera. But it wasn't a story about just one character. Because of that, there were various camera and character views, so connecting the scenes correctly was important. Even though the actor is performing, the player's view is limited, so we had to take into consideration how to express that within the camera. (Rosanna)

Many games up until now had certain in-game elements: parts where the players performed actions and then cutscenes that would advance the story. Of course, in this game, things occur during cutscenes, but those events are for the purpose of furthering the things that occur live in the actual game. Players aren't meant to focus on them just for advancing the story. So I feel it's different than the repetition of "gameplay, cutscene" in games until now. (Navid)

WHAT I FOUND INTERESTING ABOUT A GAME MADE IN JAPAN, BUT ACTED OUT IN AMERICA WAS THAT THEIR IMAGE AND OUR IMAGE OF AMERICANS IN THE SOUTH WERE COMPLETELY DIFFERENT.

On that front, the difference in our values and national characteristics came up, but sharing and reconciling those things to figure out where we should land was fun. (Rosanna)

For example, if I wanted to make a Japanese game, I would definitely search for a partner company in Japan and get people who understood Japanese game companies and Japan to help make the product. And American players would understand that it's a Japanese game. That would be ideal. It was the same for them. The backdrop for the game is the American south. Instead of just taking a stereotypical image, they looked for a partner company in the south and actually filmed would look at and say "that's the American south." It's something players worldwide would look at and understand, and I think that's amazing. (Navid)

SCENES YOU WANT THE AUDIENCE TO SEE

There are a lot of vomiting scenes which are fun, so please watch them. (Laughs) That aside, what I look forward to the most is the actual gameplay. Exploring the stage, looking around in first-person, and combat. Overall, I feel like the quality of information is high. I'm also involved with the sound recording, so I hope players will experience unease, fear, and anxiety while playing and feel their own pulse racing. (Navid)

I would like them to especially focus on the feeling of fear. There are a lot of crazy characters, and the stage and backdrops are creepy. Since it's a horror game, I hope they can enjoy that aspect. (Rosanna)

JUNE 14, 2016 ANNOUNCEMENT TRAILER

Screenshots from the first official *Resident Evil 7* trailer. Looking back, it's clear that it encompassed the important story themes.

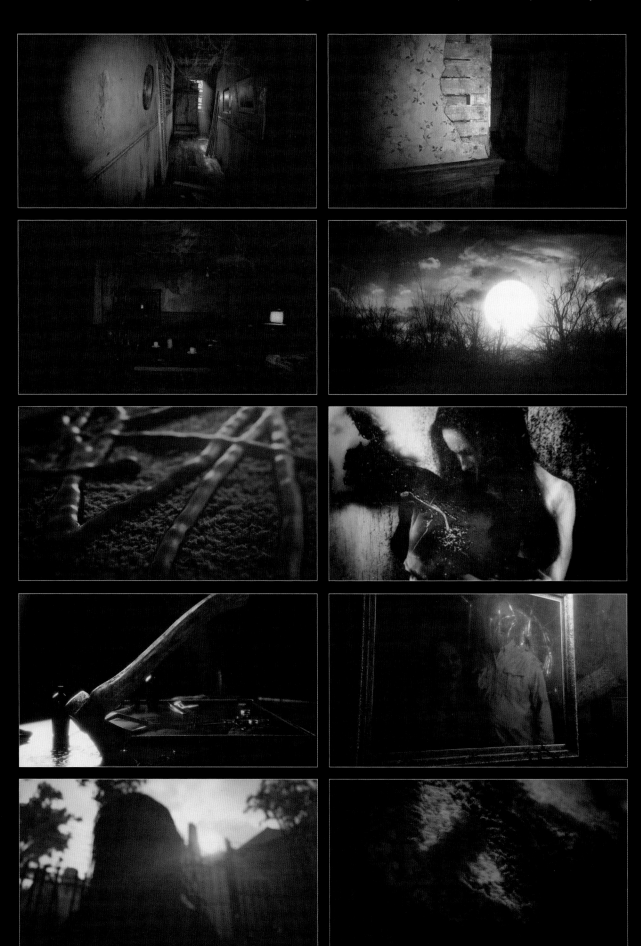

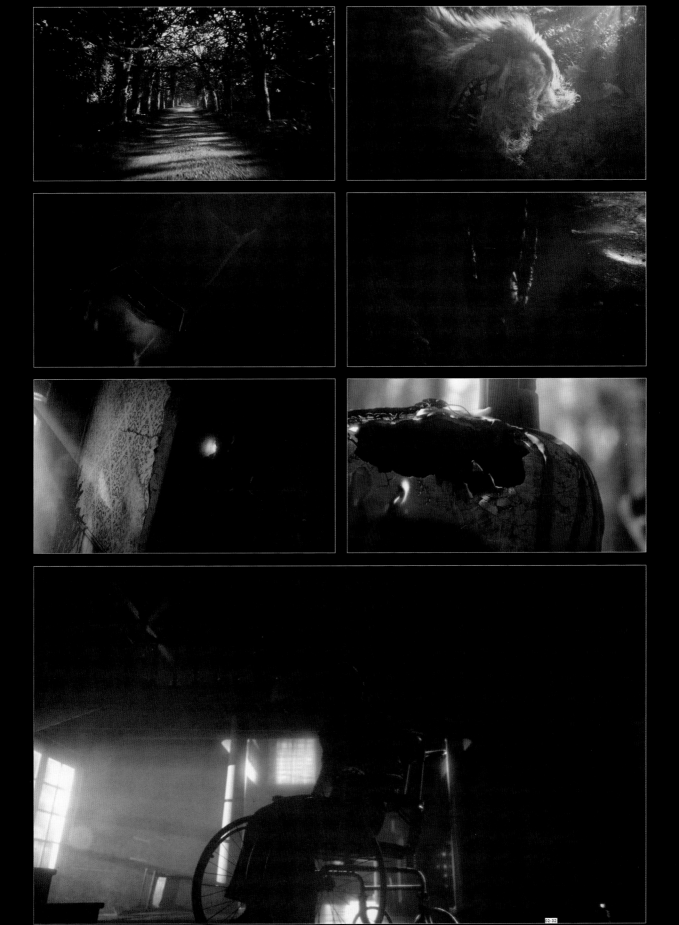

JUNE 14, 2016 E3 ELECTRONIC ENTERTAINMENT EXPO

On June 13, 2016 (Pacific Standard Time) at the E3 2016 PlayStation® Press Conference, *Resident Evil 7: Biohazard* was finally announced.

"When I was watching that day at the conference, there was hardly any reaction until the end of the trailer, so I was honestly uneasy. All the other titles were high-quality. When the title appeared at the end, there was excited cheering. When the sale date and demo were announced, the entire audience applauded, and I felt overjoyed. The hardships and unease I had felt until then disappeared, and I felt rewarded. To tell the truth, I actually cried a little." (Masachika Kawata)

JUNE 28, 2016 AMBASSADOR

The *Resident Evil* Ambassador Program aims to deliver and spread information to series fans via SNS and blogs.

An information exchange conference called the "Ambassador Meeting" was held in August, October, and November 2016. Participants could hear special talks about the game themes and development secrets directly from the team members like Mr. Kawata. (Held in Tokyo during August/October and Osaka in November.)

AUGUST 18, 2016 GAMES CONVENTION

Gamescom in Cologne, Germany. The producers fly all over the world without a moment to rest.

AUGUST 26, 2016 CEDEC [COMPUTER ENTERTAINMENT DEVELOPERS CONFERENCE]

Unveiling the precious photogrammetry set presented at a game developers conference.

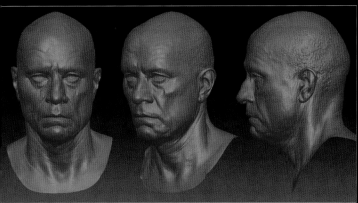

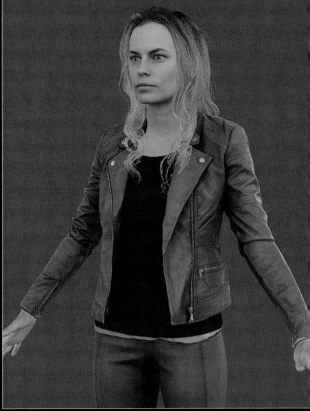

MISSION IMPOSSIBLE

1. A shorter development cycle than before.
2. Fewer human resources than before.
3. More assets than before.
4. A more photorealistic quality than before.

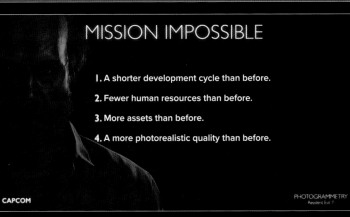

CAPCOM

PHOTOGRAMMETRY
Resident Evil 7

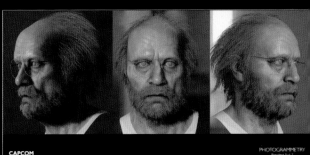

CAPCOM

PHOTOGRAMMETRY
Resident Evil 7

100 DSLR

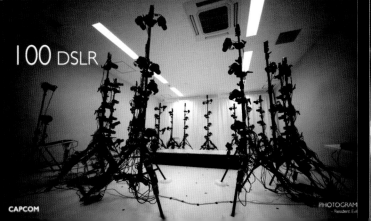

CAPCOM

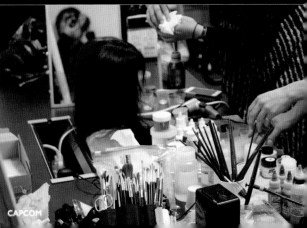

CAPCOM

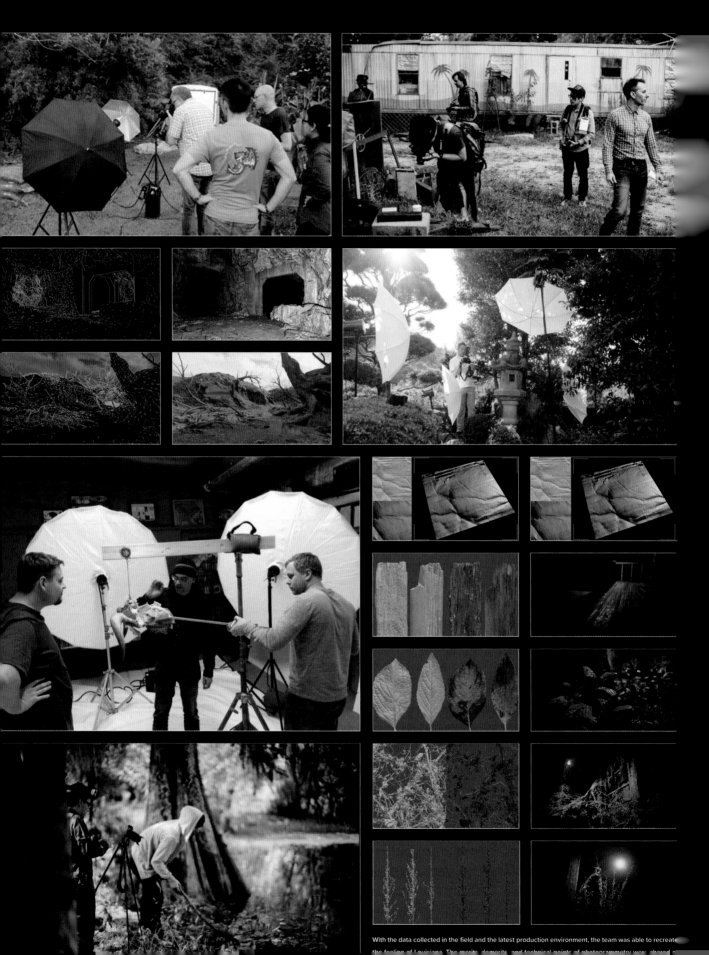

With the data collected in the field and the latest production environment, the team was able to recreate
the feeling of Louisiana. The merits, demerits and technical points of photogrammetry were shared a

SEPTEMBER 15, 2016 TOKYO GAME SHOW

t was unveiled in September during Tokyo Game Show 2016. They assembled a booth
hat looked like the Baker residence and ushered in crowds of fans.

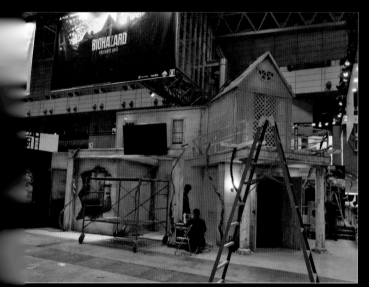

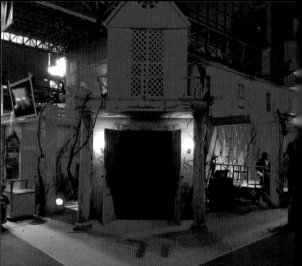

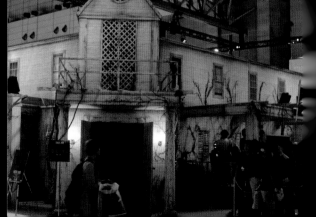

2016 CAPCOM TOKYO & OSAKA, JAPAN

After making it through the sweltering summer in 2016, development was approaching a climax. Media coverage was also heating up. In order to provide value to the game, producers and directors continue work every day. In that environment, the full story of *Resident Evil 7* finally bore fruit.

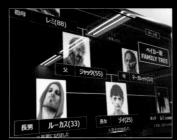

A corner of the development floor was overflowing with reference photos and progress charts. At its peak, it was a battlefield.

2016 "ALPHA" REVIEW

Adjusted to be playable, the so-called alpha version was done.
The development team, including Mr. Takeuchi, exchange frank
opinions to boil down the "fear."

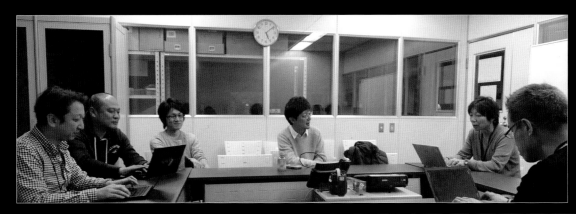

JANUARY 2017 COMMERCIAL FIRM

Promotional activities are in their final stages in early 2017.
Commercials are checked by many staff members.

Go Tell Aunt Rhody

Michael A.Levine feat. Jordan Reyne

Go tell Aunt Rhody x3
that everybody's dead

I was raised in a deep, dark hole
a prisoner with no parole
they locked me up and took my soul
ashamed of what they'd made

Go tell Aunt Rhody x3
that everybody's dead

I called to him and he will come
she'll run to him like he's the one
his arms outstretched, but when she's done
he'll be torn apart

Go tell Aunt Rhody x6
that everybody's dead

Storyboards

Below you can find precious storyboards. There are important scenes like the battle with Mia and the ending, but some of scenes were not used because they were materials during development.

Please be aware that this is not necessarily "true" information.

"Are you the one who called us?

What in the world is—"

SHINK

THUD . . .

SWIPE

SPLAT

CLANG

Break lock. Escape.

First battle.

SHINK

CRASH

SLIDE

Second battle.

SNAP

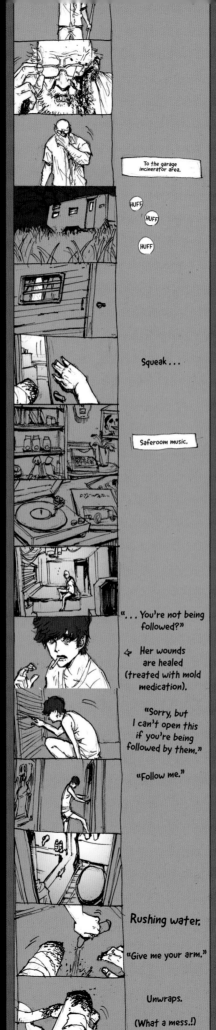

To the garage incinerator area.

HUFF HUFF HUFF

Squeak . . .

Saferoom music.

"... You're not being followed?"

Her wounds are healed (treated with mold medication).

"Sorry, but I can't open this if you're being followed by them."

"Follow me."

Rushing water.

"Give me your arm."

Unwraps.

(What a mess.!)

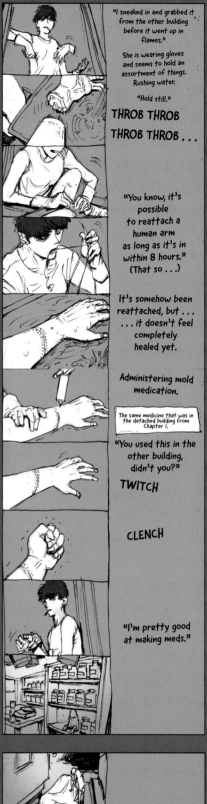

"I sneaked in and grabbed it from the other building before it went up in flames."

She is wearing gloves and seems to hold an assortment of things. Rushing water.

"Hold still."

THROB THROB

THROB THROB . . .

"You know, it's possible to reattach a human arm as long as it's in within 8 hours."
(That so . . .)

It's somehow been reattached, but . . .
. . . it doesn't feel completely healed yet.

Administering mold medication.

The same medicine that was in the detached building from Chapter 1.

"You used this in the other building, didn't you?"

TWITCH

CLENCH

"I'm pretty good at making meds."

SWISH

An older model lifeboat.

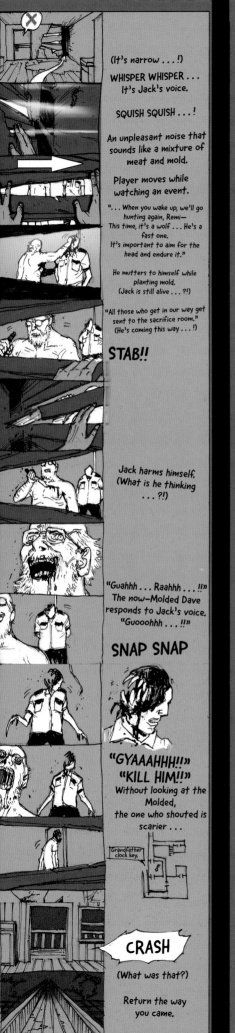

(It's narrow . . . !)

WHISPER WHISPER . . .
It's Jack's voice.

SQUISH SQUISH . . . !

An unpleasant noise that sounds like a mixture of meat and mold.

Player moves while watching an event.

". . . When you wake up, we'll go hunting again, Remi— This time, it's a wolf . . . He's a fast one. It's important to aim for the head and endure it."

He mutters to himself while planting mold. (Jack is still alive . . . ?!)

"All those who get in our way get sent to the sacrifice room." (He's coming this way . . . !)

STAB!!

Jack harms himself. (What is he thinking . . . ?!)

"Guahhh . . . Raahhh . . . !!" The now-Molded Dave responds to Jack's voice. "Guooohhh . . . !!"

SNAP SNAP

"GYAAAHHH!!" "KILL HIM!!" Without looking at the Molded, the one who shouted is scarier . . .

Grandfather clock key.

CRASH

(What was that?)

Return the way you came.

". . . Uahhh

Ahhh!!"

". . . Kevin! Where are you . . . !! Honey! Dinner is reaaady . . . "

Consciousness in disorder.

"Samara . . . I'm sorry!"

"Hurry! This way!"

"Get in!"

"Ethan! Hurry!"

THUD

"Huh . . . !
. . . Annabelle? What are you doing . . . ?!"

"Papa . . . I'm done with killing people."

"No . . ."

"—?"

"Who are you . . ."

STAB

". . . Papa . . . ?!"

"You won't get away, you worm . . . !"

"Ethan! He's coming! Start the boat!"

VRR VRR VRR

VROOOM

"AHHH!!!"

SPLASH . . .

Chapter 4

"Sorry, but I need you to stick around a little longer."

THUD

Insert cutscene to explain the situation.

Player switches to Mia.

A giant structure stands, towering (after the boat runs aground).

The road along the way is collapsing.

Last boss fight.

BANG

GYAAAAAH

Defeat the last boss.

Uooоh . . .

The last boss recovers.

GRAB

A laser sight appears.

BANG

THUD

"Oof!"

PEW

BANG

". . . !!?»

A cutscene here may be good.

TZIIING

RATTLE

"Target eliminated.
Collecting sample."

"Got it."

TAP

TAP

TAP

After making sure there are no enemies nearby, puts gun away.

"You did well making it this far alone . . . it must have been tough for an amateur."

"Taking off."

"WHUP WHUP WHUP"

". . . Can you stand?"

"Captain Chris. We collected the target sample. . . . It's as we expected. A new strain, type B."

"It's a hit. Send over the helicopter. I've found us a trophy Yes. Quite a fresh one, too."

GRAB

HUFF

HUFF

BIOHAZARD
resident evil

WHUP WHUP WHUP

HUFF

". . . Chris!"

"There's one more in the back . . ."

"Understood."

Umbrella Corporation logo.

Extra Chapter :

NOT A HERO

BIOHAZARD 7 Resident Evil Document File

Directed by Dengeki Strategy Guide Editorial Department

Director
Dengeki Strategy Guide Editorial Department
(Daisuke Kinhara)

Director ["Inside Report" Segments]
Dengeki PlayStation Editorial Department
(Yuta Shirahata)

Writer ["Inside Report" Segments]
Toru Shiwasu

Editor & Writer
TOKYO TEXT
Hajime Nakagawa
James Kuroki

Photographer
Satoshi Tokui

Original Translator
Active Gaming Media, Inc.

Text Design
TOKYO TEXT

Cover Designer
Gaku Watanabe

Producer
Takeshi Matsumoto
(Dengeki Strategy Guide
Editorial Department)

Coordinator
Yoshimichi Nishioka
(Dengeki PlayStation Editorial Department)

Special Thanks
CAPCOM CO., LTD.

Publisher
Masaaki Tsukada

Producer
ASCII Media Works

**Resident Evil 7
Biohazard Document File**

Publisher
Mike Richardson

Editors
Joshua Engledow
Patrick Thorpe

Translator
TransPerfect

Designer
Skyler Weissenfluh

Digital Art Technicians
Allyson Haller
Josie Christensen

BIOHAZARD 7 resident evil Document file was published by Kadokawa Corporation.
First edition: March 2017.

Special thanks to Megan Walker, Cary Grazzini, Ian Tucker, Dave Marshall, and Michael Gombos.

Neil Hankerson Executive Vice President • Tom Weddle Chief Financial Officer • Randy Stradley Vice President of Publishing • Nick McWhorter Chief Business Development Officer • Dale LaFountain Chief Information Officer • Matt Parkinson Vice President of Marketing • Vanessa Todd-Holmes Vice President of Production and Scheduling • Mark Bernardi Vice President of Book Trade and Digital Sales • Ken Lizzi General Counsel • Dave Marshall Editor in Chief • Davey Estrada Editorial Director • Chris Warner Senior Books Editor • Cary Grazzini Director of Specialty Projects • Lia Ribacchi Art Director • Matt Dryer Director of Digital Art and Prepress Michael Gombos Senior Director of Licensed Publications • Kari Yadro Director of Custom Programs • Kari Torson Director of International Licensing • Sean Brice Director of Trade Sales

Published by Dark Horse Books
A division of Dark Horse Comics LLC
10956 SE Main Street
Milwaukie, OR 97222

DarkHorse.com • Capcom.com

Facebook.com/DarkHorseComics
Twitter.com/DarkHorseComics

First Dark Horse Books edition: December 2020
ISBN 978-1-50672-166-8

10 9 8 7 6 5 4 3 2 1
Printed in Singapore

Library of Congress Cataloging-in-Publication Data

Names: Capcom USA, author.
Title: Resident Evil 7 : Biohazard document file / Capcom.
Description: First edition. | Milwaukie, OR : Dark Horse Books, a division
 of Dark Horse Comics, LLC, [2020] | Summary: "An in-depth, 152-page art
 book that ventures into the challenges recorded throughout the
 production of the critically acclaimed, fan-adored Resident Evil 7:
 Biohazard! Relive the terror of Resident Evil 7: Biohazard, the expertly
 crafted first-person survival horror game that altered the paradigm of
 Resident Evil titles. This art book includes undisclosed concept art and
 CG visuals closely arranged and coupled with detailed passages of the
 development team's progress on the game. Explore interviews, photo
 albums, a storyboard collection of in-game event scenes from opening to
 ending, and more in this succinctly packed chronicle of Resident Evil
 7's development. Dark Horse Books and Capcom present Resident Evil 7:
 Biohazard Document File, a perfect companion for fans of Resident Evil,
 and fully translated to English for the first time!"-- Provided by
 publisher.
Identifiers: LCCN 2020012991 | ISBN 9781506721668 (hardcover)
Subjects: LCSH: Resident Evil 7 (Video game)
Classification: LCC GV1469.35.R47 C36 2020 | DDC 794.8--dc23
LC record available at https://lccn.loc.gov/2020012991